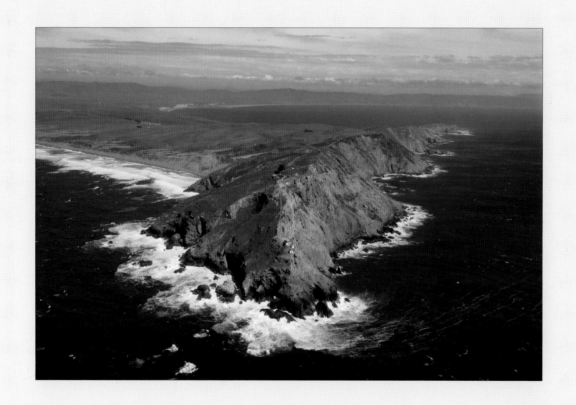

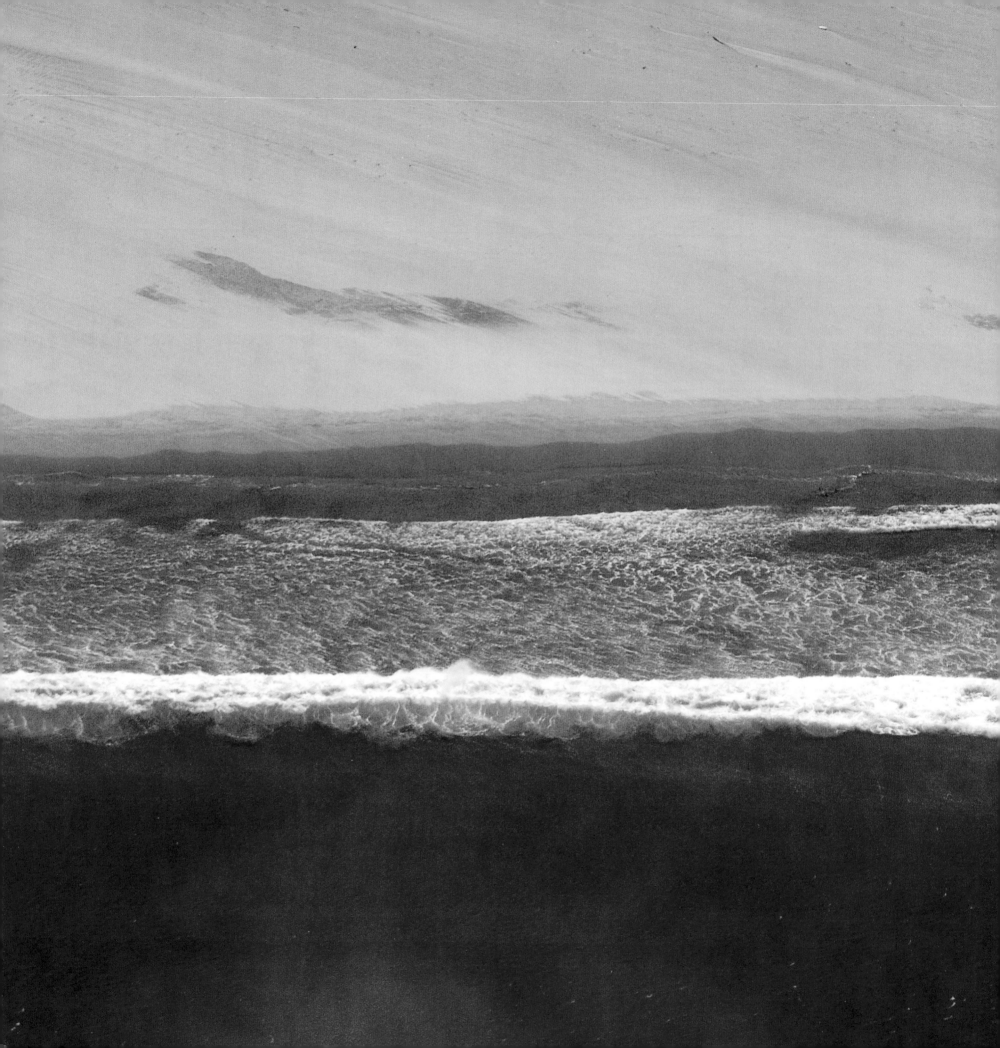

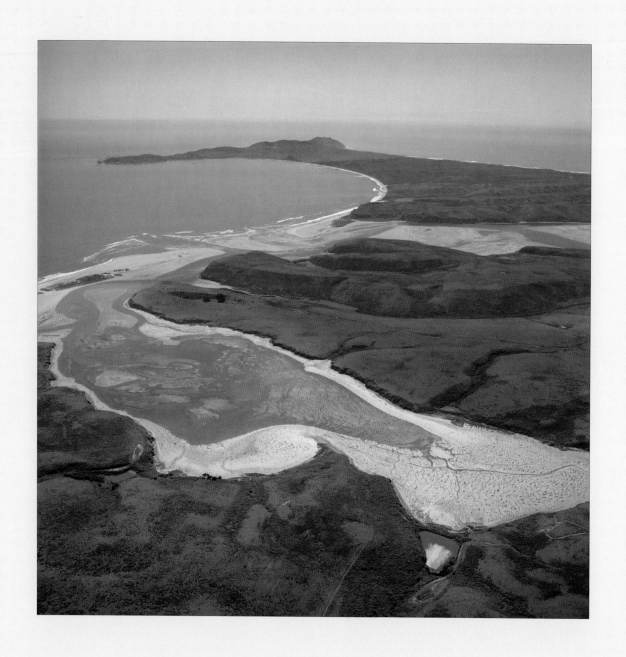

POINT REYES

and the San Andreas Fault Zone

AERIAL PHOTOGRAPHS

BY ROBERT CAMPBELL

Text by Frank Binney

CHAMOIS MOON PRESS

2008

First Editions

Library of Congress
ISBN softcover: 978-0-9799453-0-4
ISBN hardcover: 978-0-9799453-1-1

© 2008 Chamois Moon Press
www.chamoismoon.com
www.robertcampbellphotography.com

All photographs: © ROBERT CAMPBELL

Requests to make copies of any
part of the work should be mailed to:
Chamois Moon Press, P.O. Box 1982
Sonoma, CA 95476 866 996 8338
e-mail: info@chamoismoon.com

Printed in Hong Kong.

Cover image:
THE POINT REYES PENINSULA
AND DRAKES BAY

Graphic Design: MADELEINE GRAHAM BLAKE
Back Cover image: ERIC PRESTON

First Image:
LIMANTOUR BEACH

Frontispiece:
LIMANTOUR ESTERO, DRAKES BAY
AND THE HEADLANDS

Quote on page viii:
ANTOINE DE SAINT-EXUPÉRY (1900–1944)
"WIND, SAND AND STARS"
©1939, 1967 HARCOURT, INC.
USED BY PERMISSION

Dedicated to my father,
Douglas Gordon Campbell, M.D.,
for introducing me to the
wonders of flight trough his own aerial photographs
and movies when I was very young.

To my mother,
Marian VanTuyl Campbell,
for encouraging me
to pursue my interest in
art and aerial photography,

And to both of them
for insisting
that whatever I did, I did well.

Robert Campbell
Sonoma, California 2007

THE AEROPLANE HAS UNVEILED FOR US THE TRUE FACE OF THE EARTH.

– Antoine de Saint-Exupéry (1900–1944)

POINT REYES *and the San Andreas Fault Zone*

AERIAL PHOTOGRAPHS BY ROBERT CAMPBELL

TABLE OF CONTENTS

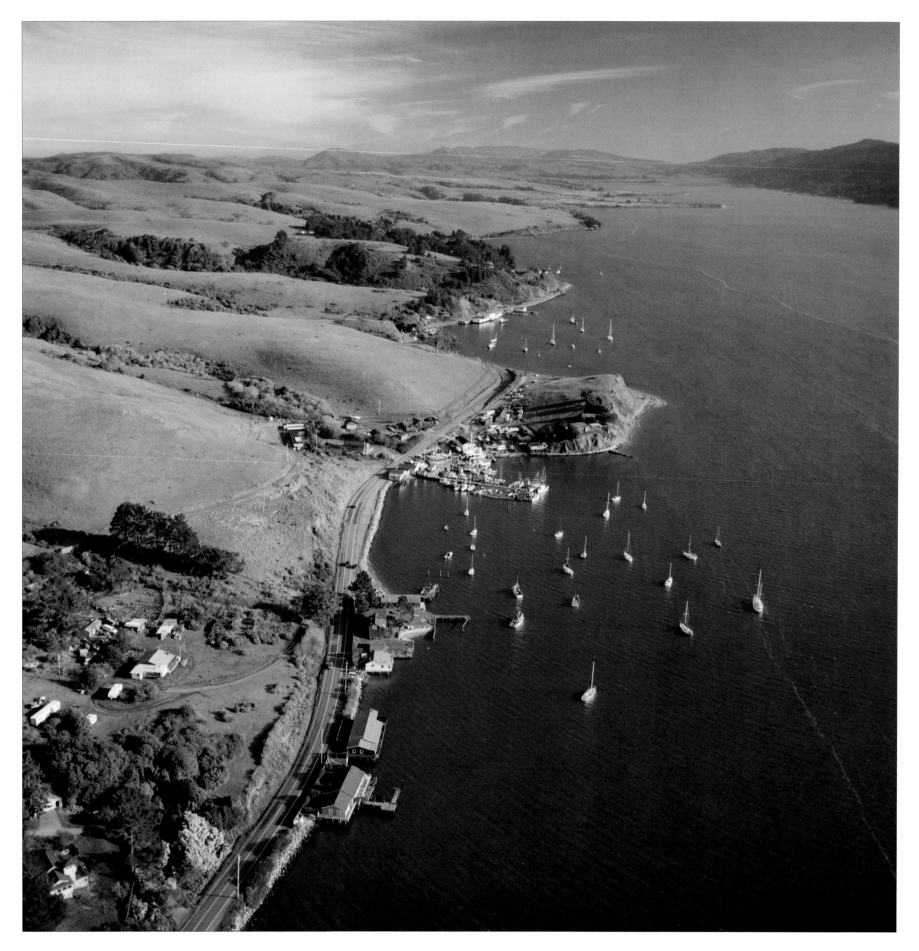

Prologue

As a California native, long-time host of "Bay Area Backroads" on KRON Television in San Francisco, and the co-founder of a regional travel website, "www.openroad.tv", people often ask me to reveal my favorite place in the Bay Area. That's almost impossible for me to answer. I have too many favorites to easily select only one. So, usually, I hem and haw for a bit and then admit the truth, that it is and has always been Point Reyes National Seashore and its neighborhood.

Nature, history and geography combine to make Point Reyes beautiful, diverse and fascinating. It's a sanctuary for wildlife, a window on our past and a refuge for the human spirit. And it was almost lost to highways, marinas and suburban sprawl. Thankfully, dedicated local residents, determined conservationists and wise public servants saved Point Reyes from bulldozers and concrete. The unique and irreplaceable values of Point Reyes will be protected for generations to come.

It is important to note that Point Reyes won't be a part of the Bay Area forever. After all, it rests atop the Pacific tectonic plate, and is moving northwestward every year. Sometimes, as in the 1906 earthquake and interpreted along the Earthquake Trail in Bear Valley, it can lurch forward many feet in a single instant. But usually, it just inches along its northwestward trajectory. Stay aboard, and in a few million years, you'll ride Point Reyes all the way to Alaska. I call it "The World's Slowest Cruise Ship." It's also the most scenic, and now you can see its visual wonders from a whole new perspective thanks to this wonderful book by Robert Campbell.

Bob's a brilliant and sensitive photographer. I've flown with him above Point Reyes and watched him work his magic. Fortunately, he's now sharing his magic and his perspective with all of us. I urge everyone to enjoy the flight and Bob's extraordinary view, and then visit Point Reyes as often as possible. It may become your favorite, too.

Doug McConnell
San Francisco, California 2007

◀ Highway One and the Town of Marshall Looking Toward the Olema Valley
March 1995

▲ Point Reyes National Seashore
Bear Valley Visitor Center
May 2006

Foreword

FOR THE MANY VISITORS WHO TRAVEL TO THE POINT REYES NATIONAL SEASHORE each year, the landscape is magnificent from any perspective. The park's interface with the fertile Pacific Ocean creates the setting for spectacular scenery ranging from towering white cliffs rising above Drakes Beach to views of formations of brown pelicans soaring above crashing waves. On the ground, visitors have the chance to interact with a rich diversity of plants and animals including tule elk, elephant seals, sea lions and sea stars. Because of this bounty of wildlife, Point Reyes has been often been called "Yellowstone West."

From an aerial perspective, the park's magic is expansive, and its beauty is even more revealed. The sweeping coastline, wind-swept beaches, towering forests, jutting granite headlands, and sinuous estuaries create a mosaic of dramatic scenery that leaves one in awe of nature's creative work. Fog banks, cumulus clouds and reflections from the abundant waterways further deepen colors and moods created by the park's coastal setting.

In this book, Robert Campbell captures the essence and spirit of this phenomenal national park. His elegantly expressive photographs connect us to the landscape on an emotional level, deepening our appreciation of a coastal sanctuary that is one of America's national treasures. I hope these vivid images will inspire readers to visit Point Reyes to make their own connections to the natural and cultural riches of this sacred place. There are few who experience the seashore's 70,000 acres of beaches, pastoral grasslands, forests, meadows and wetlands who do not leave inspired to protect this unique peninsula for the enjoyment of generations to come.

DON NEUBACHER
Point Reyes Station, California 2007

*Don Neubacher has worked in many national parks across the United States
and currently serves as Superintendent of the Point Reyes National Seashore.*

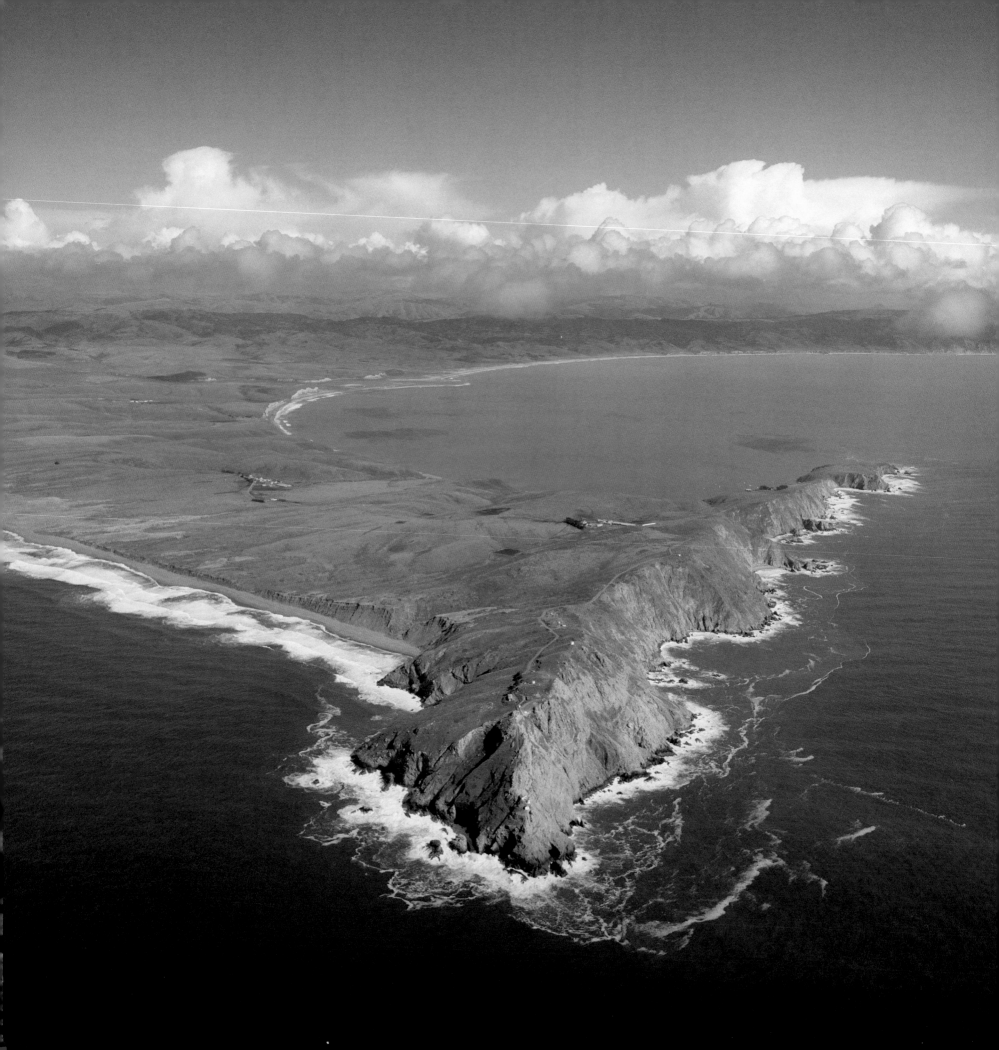

Map of the Point Reyes Peninsula

A Refuge for the Human Spirit

SEPARATED FROM THE NORTHERN CALIFORNIA MAINLAND by the long narrow bay and straight valley of the San Andreas Fault Zone, the Point Reyes peninsula resembles an island both in geography and spirit.

Drive an hour from the peninsula to the concrete sprawl girdling San Francisco Bay, and you can rub shoulders with over seven million people. Spend an equal amount of time exploring Point Reyes' scenic winding roads, and you'll likely encounter more cows and wildlife than fellow human beings. If you are willing to venture far enough into the peninsula's 150 mile network of foot trails or along its 80 miles of beaches, you are virtually guaranteed to find a piece of unspoiled nature you can enjoy all to yourself.

◀ POINT REYES PENINSULA
LOOKING OVER POINT REYES LIGHTHOUSE
AND DRAKES BAY
February 1994

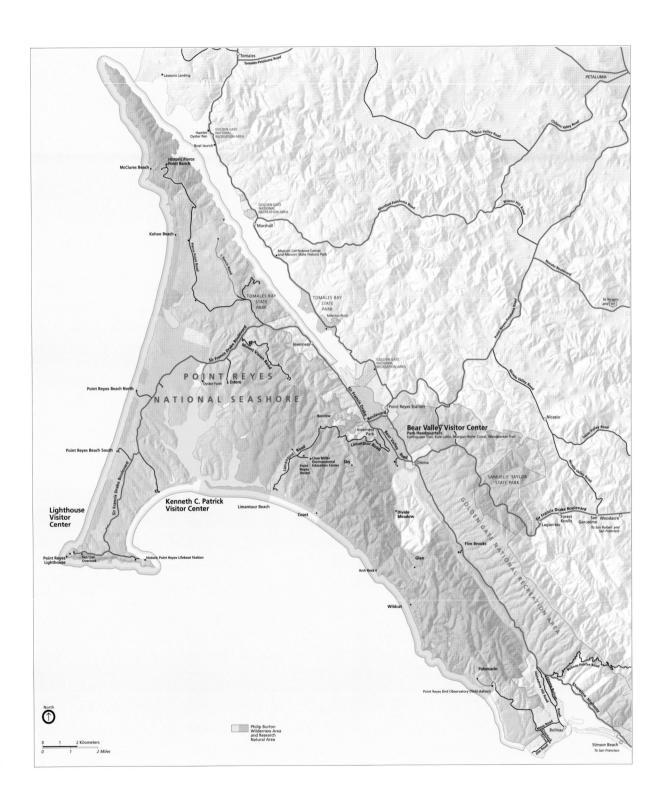

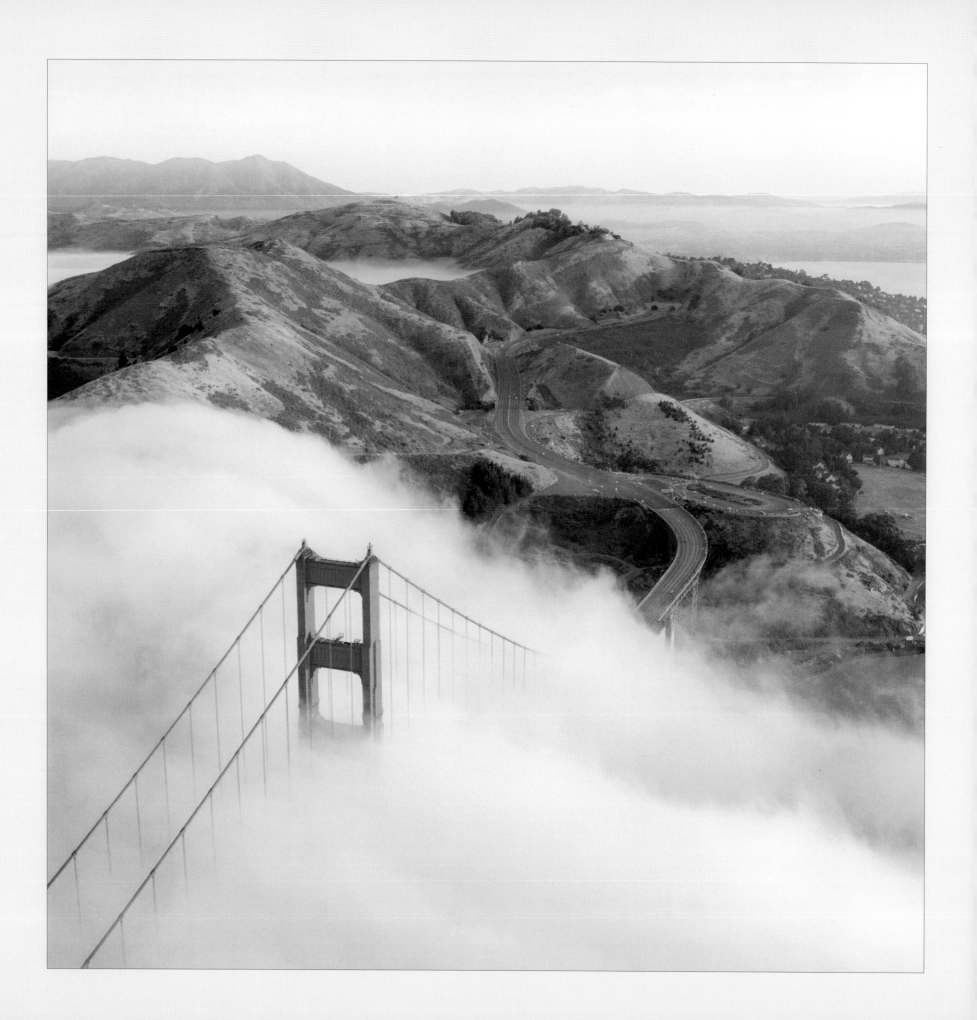

Introduction

To cross this valley to the peninsula (Point Reyes)
is to leave modern California
and enter an island of wilderness, forgotten by progress,
a quiet land misplaced in a noisy world.
– *Stephen Trimble*

You may already know this special place. Millions visit every year – drawn by the beauty of 80 miles of unspoiled coastline, the pastoral vistas of historic ranchlands and the inspiring grandeur of ancient forests; the chance to experience a personal connection with a hillside of wildflowers, a herd of magnificent elk, a mother whale and her calf breaching just beyond the surf line.

Many of us return to the Point Reyes peninsula time and time again, discovering new wonders on each visit. This especially holds true for aerial photographer Robert Campbell. For over 37 years he has made repeated flights over the peninsula and the adjacent San Andreas Fault Zone, capturing the landscape in unique compositions as the weather and seasons change. Winter storms clear the haze, summer fog softens the sunlight, spring flowers illuminate the meadows. This book is an invitation to experience the peninsula's inspiring terrain from a perspective seldom available to the ordinary visitor.

Some of Campbell's photographs reveal recognizable landmarks in views beyond our land-bound experience – a stunning panorama of the Point Reyes Headland and Lighthouse, for example, taken from a seabird's perspective. Other images, no less powerful, frame small details and patterns on the ground that speak to us with their abstract beauty.

Campbell uses his airplane the way ground-based photographers use a tall tripod or a mountaintop vista point – as a means to expand the possibilities of vision and composition. His advantage, however, is that his tripod can elevate from the ground to 20,000 feet, and he can move his mountain-height vantage point to places where there are no mountains. The result is this breathtaking collection of aerial vistas that express an artist's love for the natural and cultural treasures of one of America's last wild coastal areas, a remarkable landscape that remains little changed since the days of Miwok Indians, Mexican dons and Gold Rush pioneers.

Enjoy the tour!

◀ The Marin Headlands and Mount Tamalpais from Above the Golden Gate Bridge
June 1979

Frank Binney
Woodacre, California, September 2007

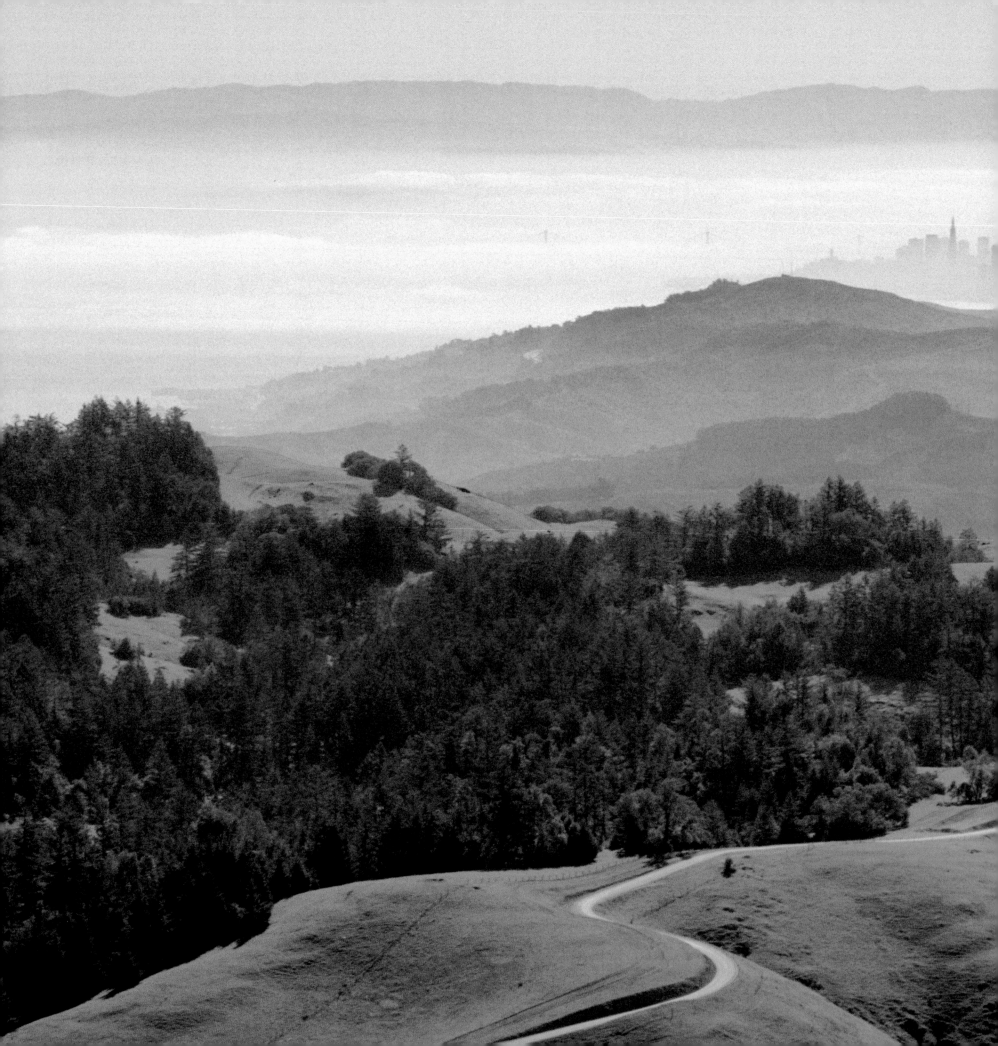

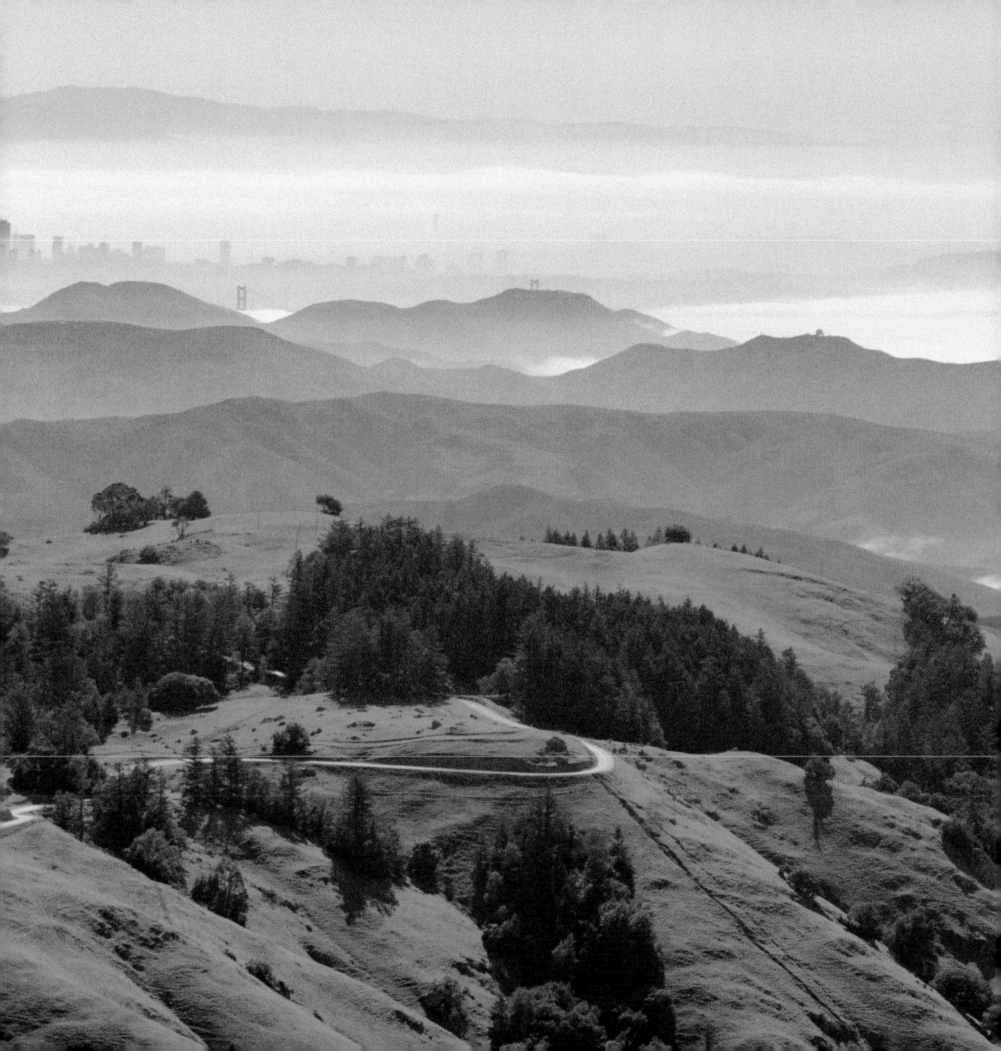

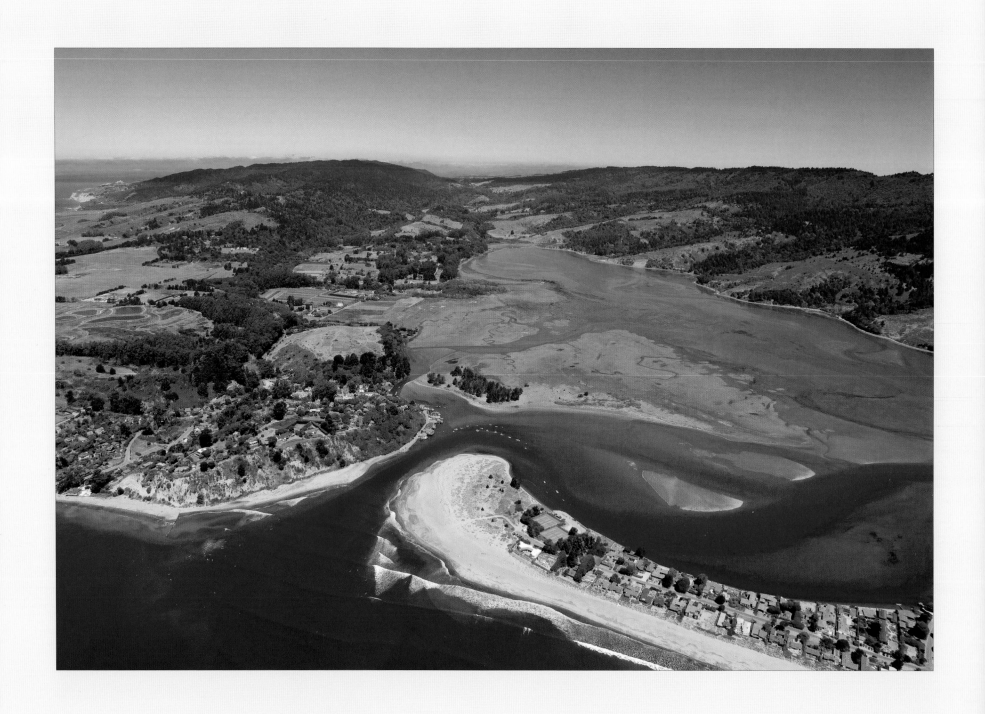

◄◄ FROM ABOVE BOLINAS RIDGE, LOOKNG OVER
SAN FRANCISCO TO THE EAST BAY HILLS
March 1974

▲ THE SAN ANDREAS FAULT FROM
BOLINAS LAGOON AND THE OLEMA VALLEY
THROUGH TOMALES BAY
July 2007

1. The San Andreas Fault Zone

An Airplane is a Good Place to be in an Earthquake

IN 1906, IF ROBERT CAMPBELL HAD BEEN AROUND and could have gotten his hands on an advanced version of the Wright Brothers' recent invention, he might have been up in the air above the Point Reyes peninsula just after 5:00 AM on the morning of April 18th, taking advantage of what the weather bureau at the time described as unusually "clear and pleasant" conditions. Locals called it "earthquake weather".

At his typical cruising altitude of 1500 ft., Campbell would have had a perfect view down the peculiar straightness of a long and narrow depression that splits the rugged hills of West Marin from the sand spit of Bolinas Lagoon northward through the sleepy village of Olema all the way to the mouth of Tomales Bay. Then, as now, that narrow valley's idyllic tapestry of tidelands, fields and forest would have presented a deceptive image of pastoral tranquility.

With his droning engine, he wouldn't have heard the sudden rumble of grinding subterranean rock that startled early-rising Olema Valley ranchers that morning – a low roar coming from the south that within seconds amplified into a deafening crescendo of ripping earth, shattering trees and bellowing livestock.

The terrifying events being experienced by those on the ground would have been barely noticeable for someone flying overhead. Long fissures ripping across pastures, dust from collapsing cottages and tumbling water tanks, the sudden realignment of fence lines and wagon roads, the splash of the Bolinas wharf toppling into the lagoon, the steam locomotive and cars of the morning train at Point Reyes Station jolted sideways off the tracks – all could have easily escaped Campbell's observation, especially if he had been distracted by the beauty of the sunrise to the east. Serene in his cockpit, his first inkling that all was not right in the world that fateful morning would probably have come when he turned his plane homeward and noticed tall columns of smoke rising skyward from the direction of San Francisco.

Today, the long straight valley where the earth moved so dramatically in 1906 draws thousands of visitors. Many probably have no idea they have placed themselves in the collision zone between two restless plates of the Earth's crust. We can only guess at what they might experience when the next "Big One" rocks this section of the San Andreas Fault. It's a good bet, however, that at least some of those on the shaking ground will wish they were somewhere else...perhaps far above, in an airplane.

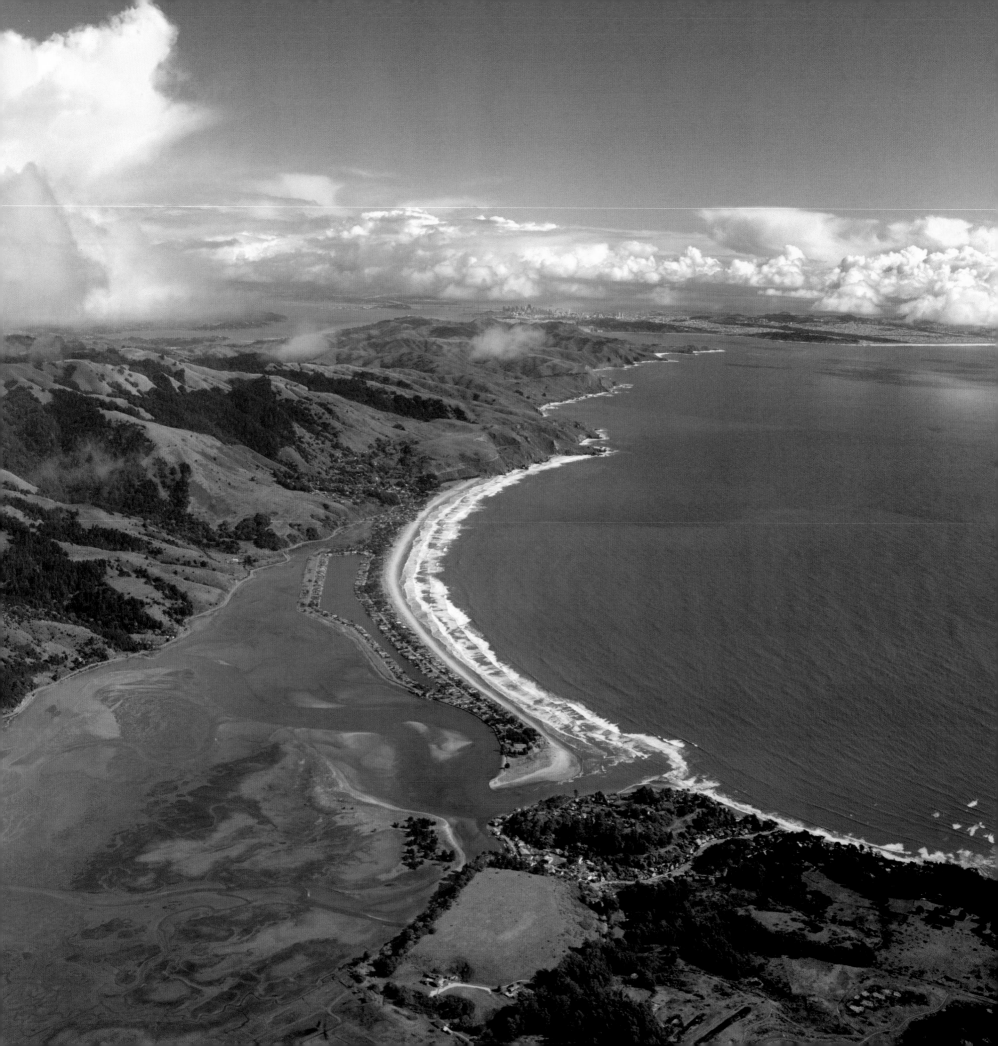

Bolinas

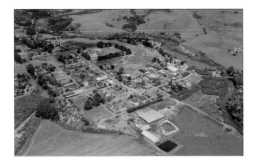

Point Reyes Station

AN ACTIVE FAULT ZONE beneath their homes has not dissuaded newcomers to the small towns at either end of the Olema Valley. The mellow beach communities of Stinson Beach and Bolinas and the old railroad hub of Point Reyes station to the north have gained residents since the big quake of '06. If planners in the 1960s had their way, even more people would live here today – a lot more.

From the air, one of the most visible features of Bolinas Lagoon is the long, suburban-style subdivision built on the lagoon's once-pristine sand spit. Similar upscale developments were envisioned throughout the Point Reyes area, serviced by a wide freeway whisking hundreds of thousands of new residents along the Olema Valley. If not for the efforts of dedicated conservationists, the photographs in this book would show a far different landscape.

Communities on Shaky Ground
Stinson Beach, Bolinas, Olema Valley, Point Reyes Station

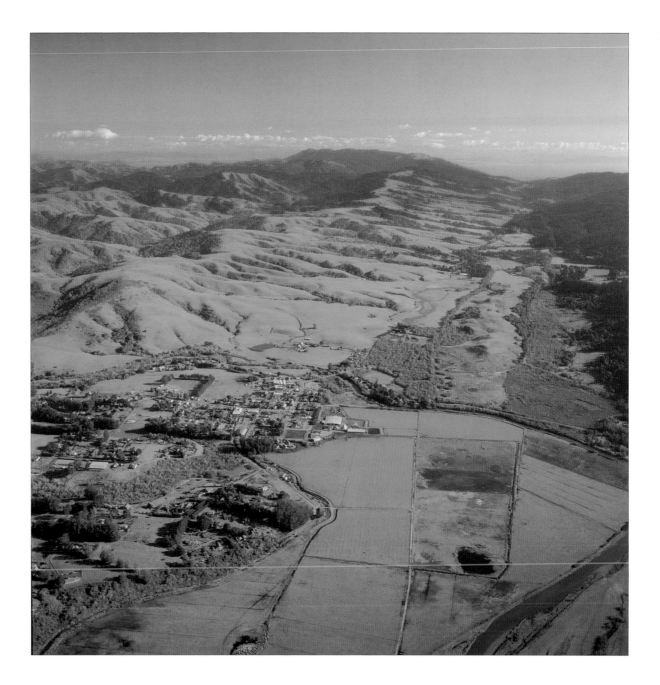

◀ BOLINAS, STINSON BEACH AND SAN FRANCISCO
February 1994

▲ THE OLEMA VALLEY
December 2001

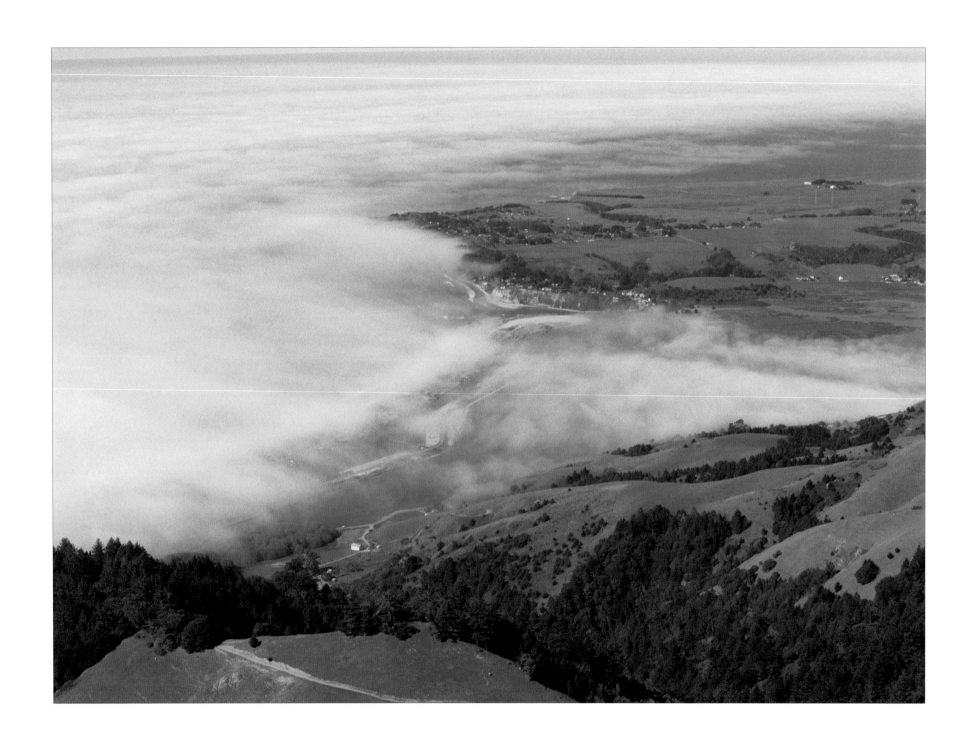

▶ Stinson Beach and Bolinas Lagoon
Looking toward Drakes Bay and the Point Reyes Headlands

March 1998

▲ Fog over Bolinas Lagoon

March 1974

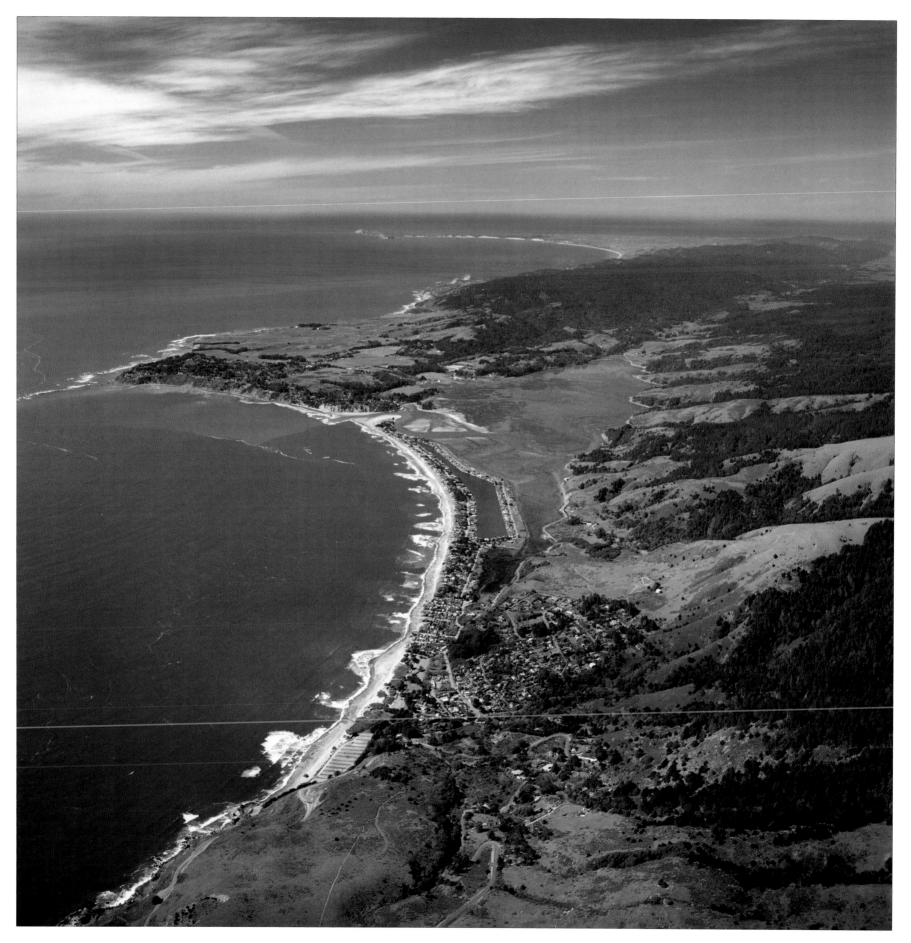

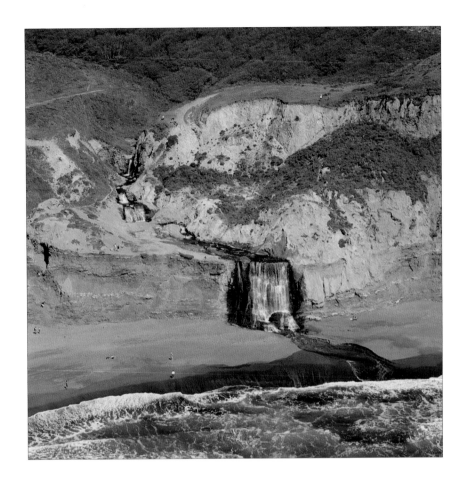
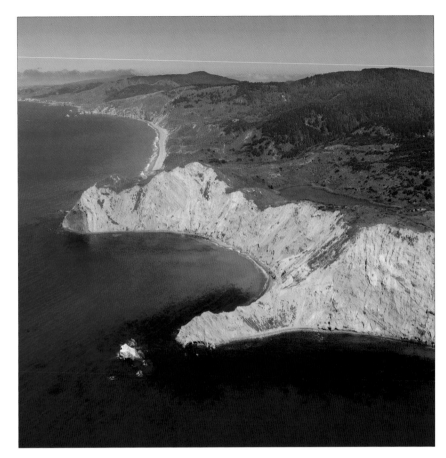

Ancient Landslides Carved by Waves

l. ALAMERE FALLS
April 1995

r. DOUBLE POINT
June 2007

▶ POINT RESISTANCE
April 1995

A NECKLACE OF FIVE SPARKLING LAKES puzzled geologists studying the coastline north of Bolinas Lagoon. Natural bodies of fresh water are rare on the Point Reyes peninsula. Most of what locals call "lakes" are ranch ponds and reservoirs. No man-made dams, however, explained the water trapped in the succession of topographic depressions just inland from the cliffs between Palomarin and Wildcat beaches. What had happened here? Investigation of the oddly broken and tilted rock strata revealed the answer – miles-long chunks of Inverness Ridge had been undercut by ocean waves, then shaken loose by earthquakes and sent crashing into the Pacific as massive landslides. The tops of these giant collapsed blocks slope landward, forming catchment basins that became today's Bass Lake, Pelican Lake, Crystal Lake and their smaller siblings. Up-tilted strata at the base of the landslides form the cliffs seen in Robert Campbell's photos of Alamere Falls and Double Point (above).

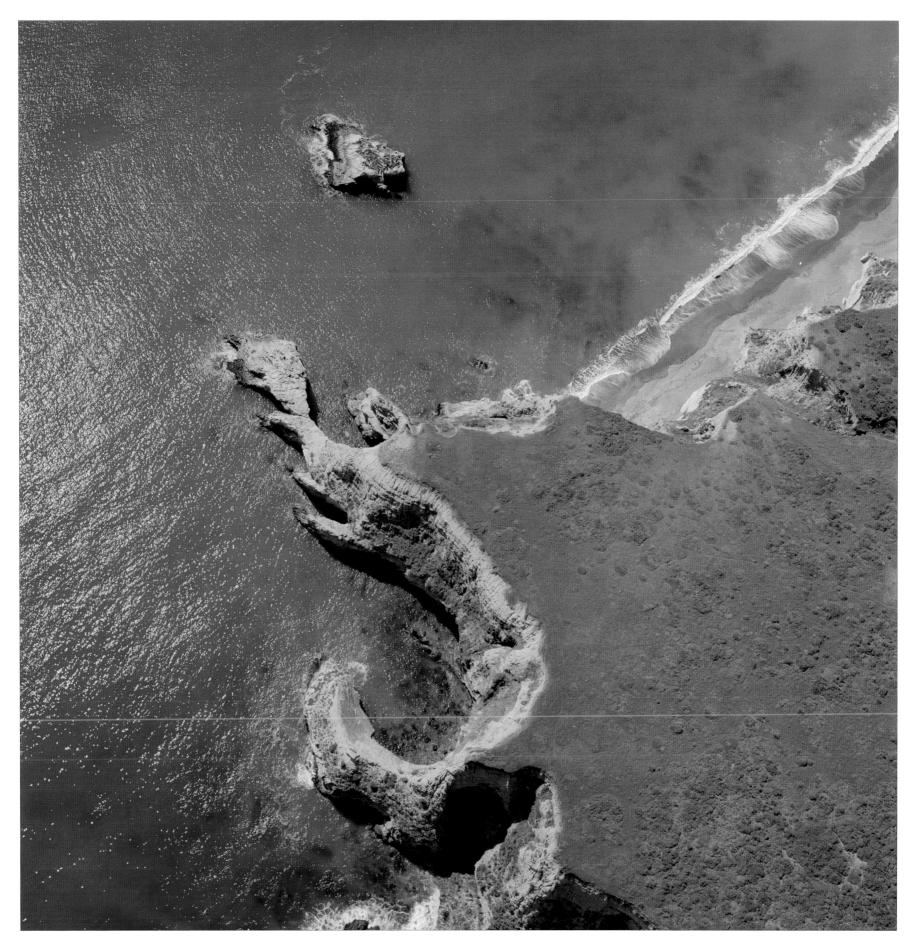

▲ Olema
May 2006

▶ Olema Valley
October 1995

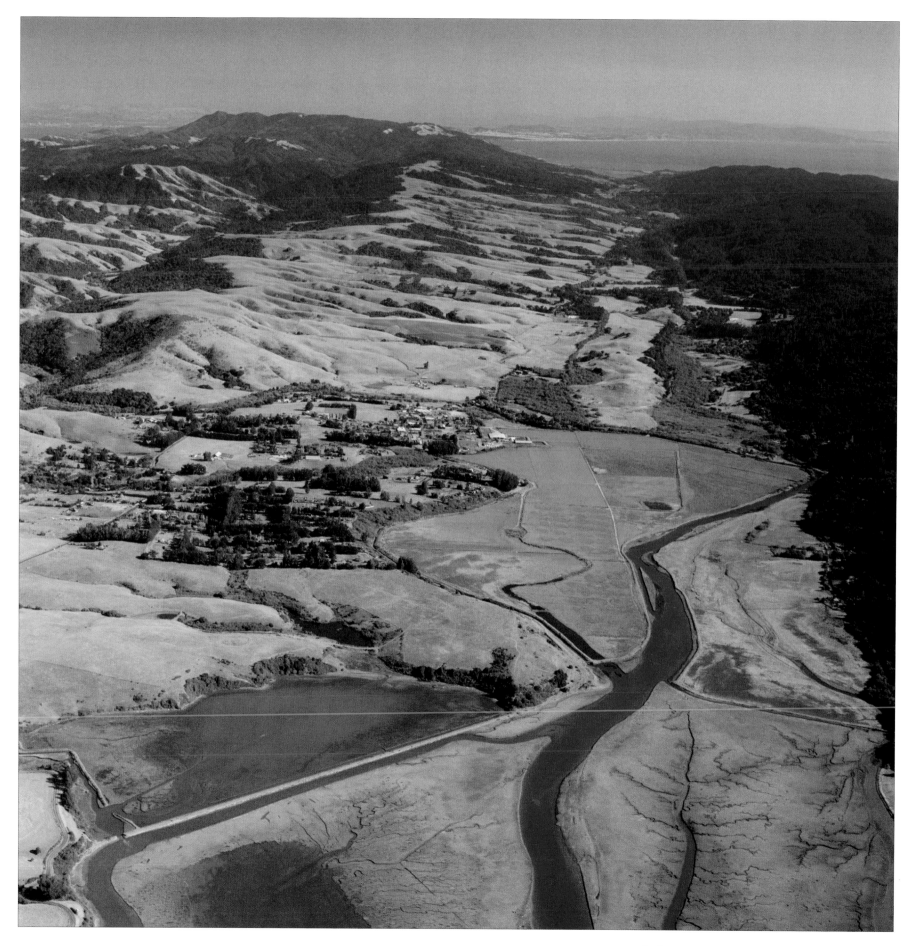

Olema Cemetery

MOST MOTORISTS ON HIGHWAY ONE speed past the nondescript gates of the tiny Olema Cemetery, clueless to its existence. From the air, however, it's hard to miss this quiet resting place of many of West Marin's pioneer ranching families. The formal rectangle of dark green cypress trees with its white mosaic of paved burial plots stands out in incongruous contrast to the surrounding grasslands of the Golden Gate National Recreation Area.

In 1882, community-minded, Swiss emigrant Joseph Bloom deeded this secluded corner of his dairy ranch for use as a burial ground by local ranchers and townspeople. Today, the eclectic collection of grave markers bears the names of a veritable "Who's Who" of West Marin history – Straus, Gallagher, Tomasini, Stewart, Truttman and many others.

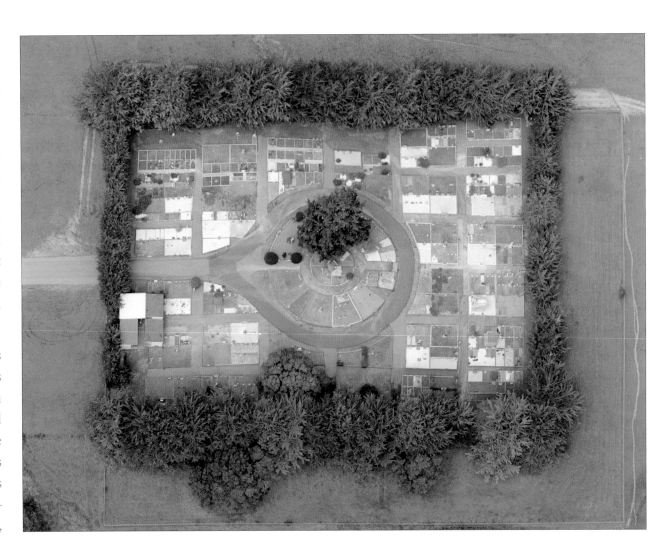

▲ THE OLEMA CEMETERY
December 2004

▶ POINT REYES STATION AND TOMALES BAY
March 1994

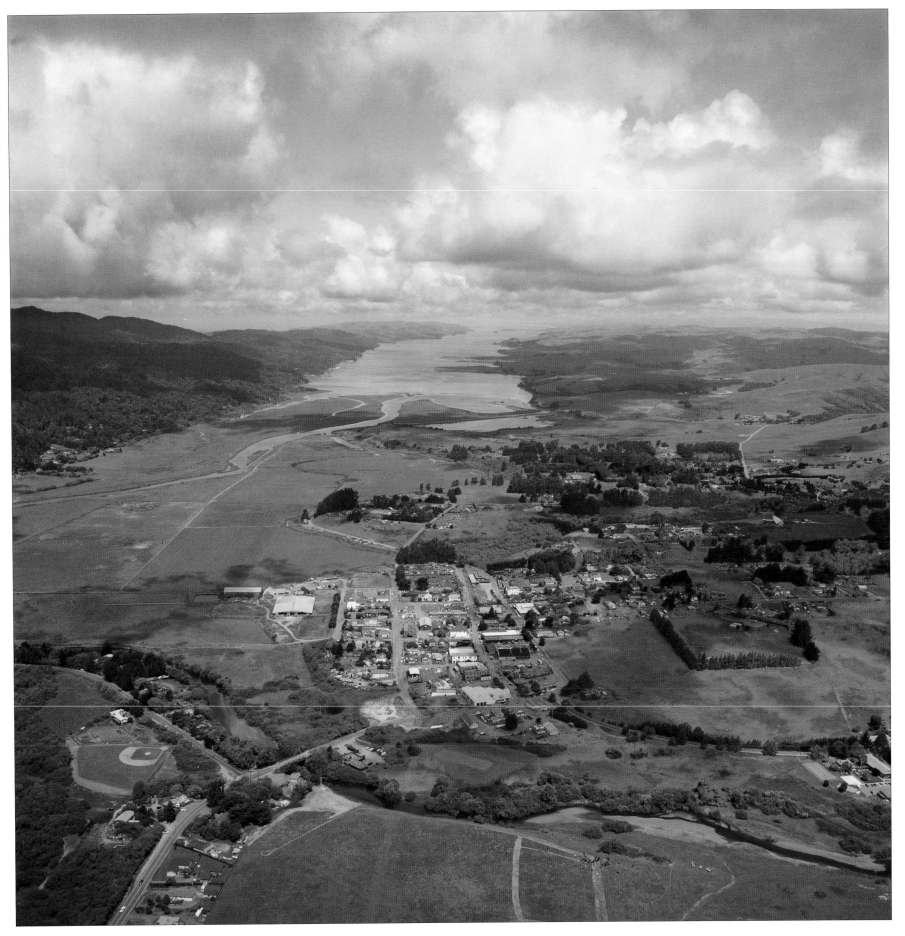

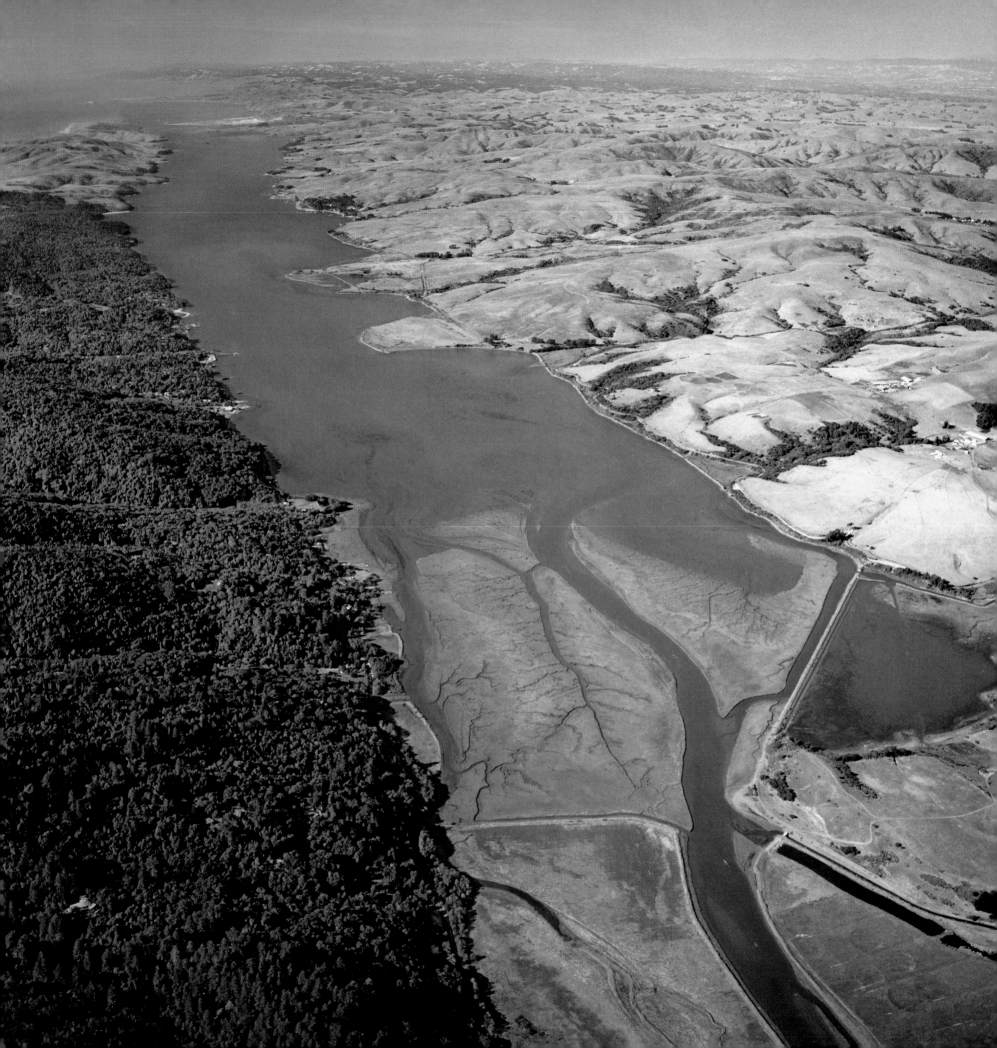

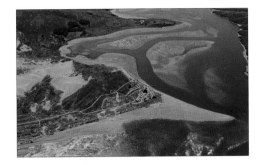

Mouth of Tomales Bay

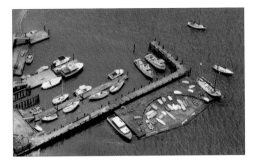

Marshall

Tomales Bay

A Fault Zone Filled with Water

OCEAN WATERS fill the San Andreas Fault Zone north of Point Reyes Station, creating a long, narrow bay that mirrors the shape of the underlying fault. During the big earthquake of 1906 a fisherman reported the bay's water suddenly emptied, leaving his boat high and dry, before rushing back in a wave almost ten feet high.

Today, Tomales Bay produces some of the West Coast's tastiest oysters and draws legions of weekenders to the rustic shoreline villages of Inverness and Marshall. The bay's waters are a favorite playground of kayakers in the morning calm, and of windsurfers and sailors in the breezy afternoons. Marshlands at the southern end of the bay nurture thousands of shorebirds and, viewed from the air, offer an ever changing palette of abstract natural patterns.

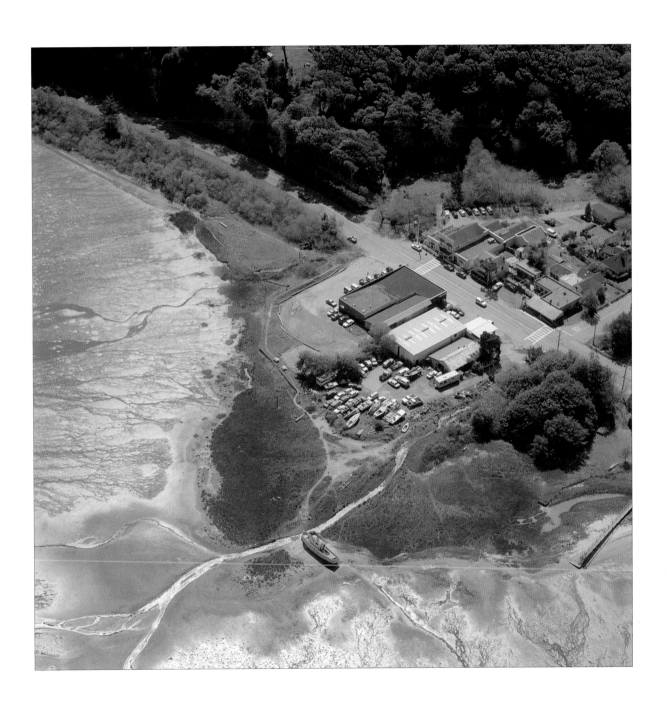

◀ TOMALES BAY
October 1995

▲ INVERNESS
May 2004

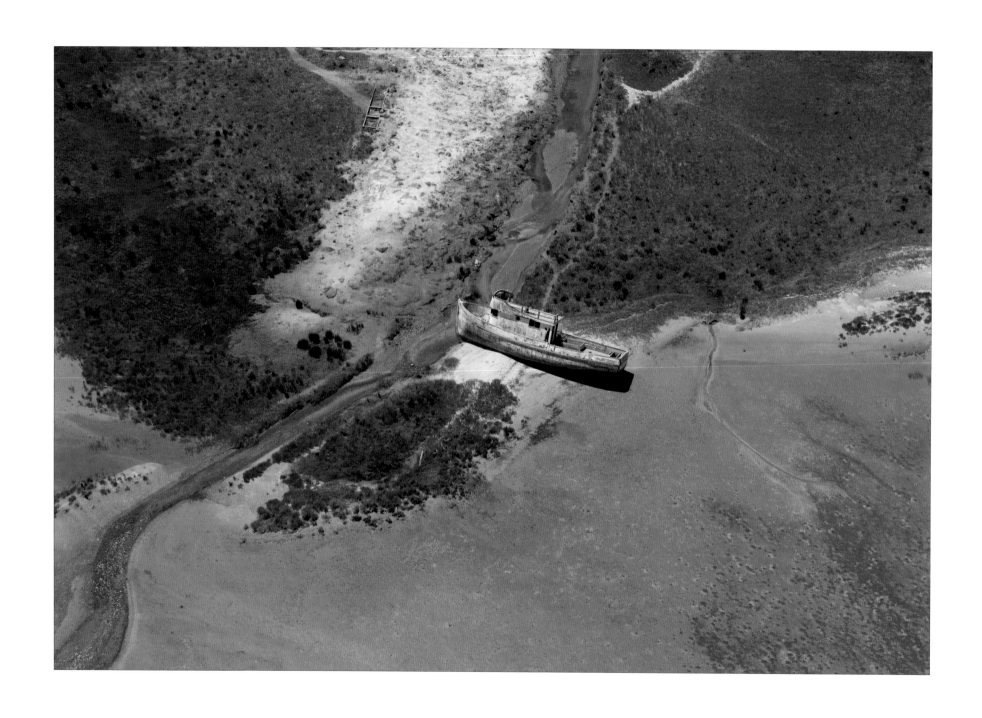

▲ FISHING BOAT, "POINT REYES"
May 2006

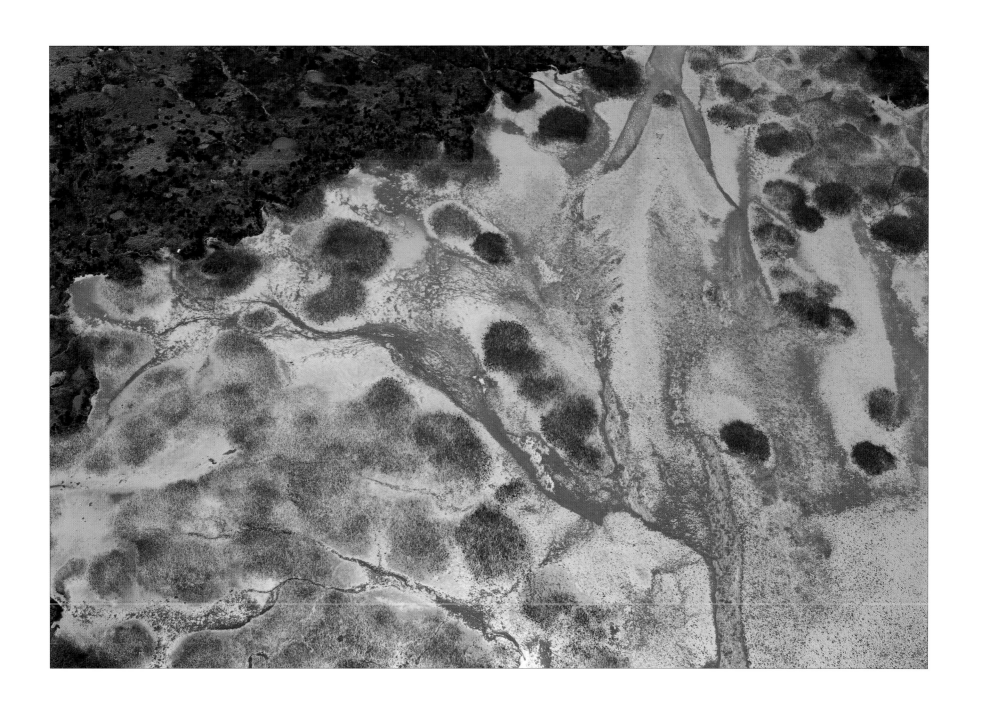

▲ TOMALES BAY DETAIL, LOW TIDE
May 2006

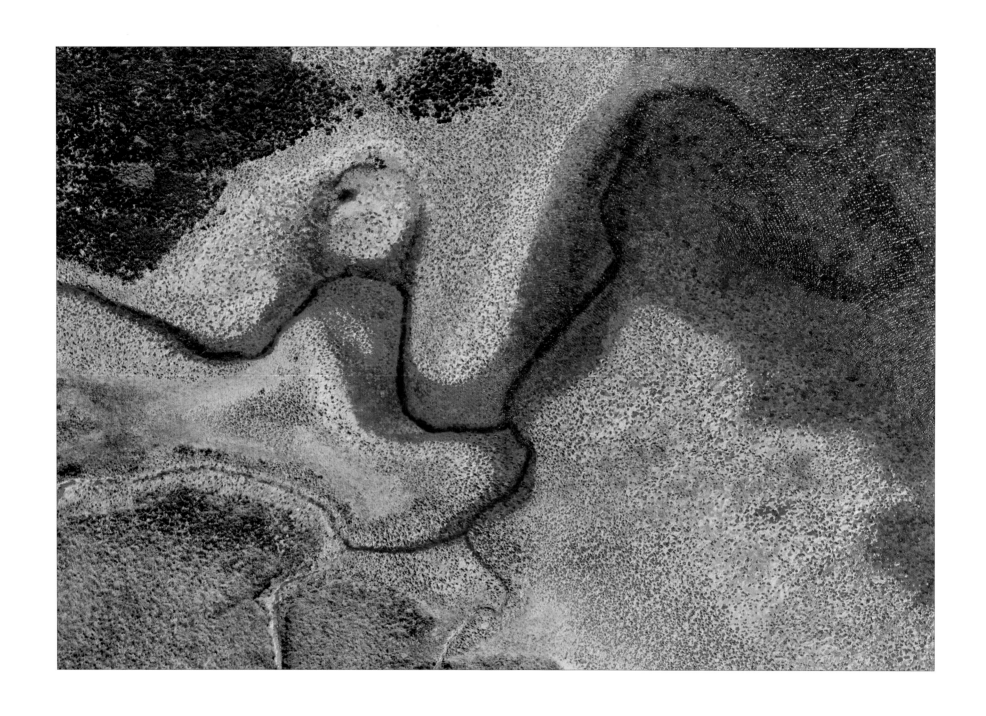

▲ TOMALES BAY DETAIL, LOW TIDE
May 2006

▶ STUDIO AND ROWING SCULLS, TOMALES BAY
June 2006

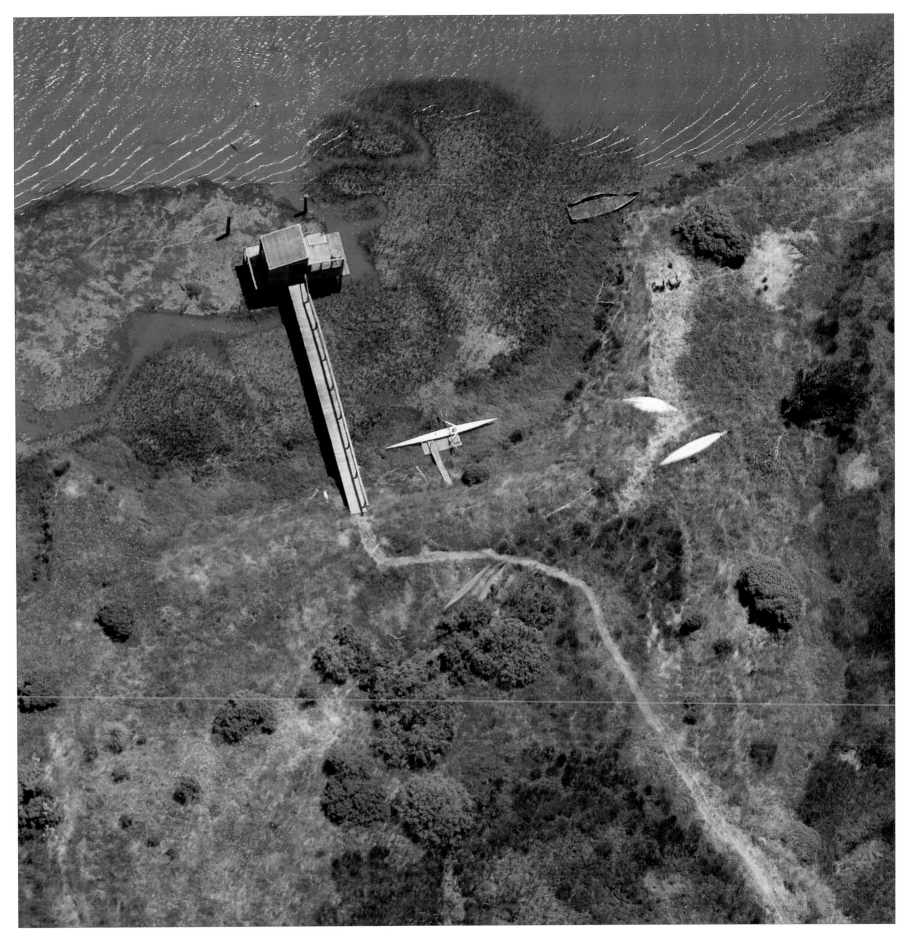

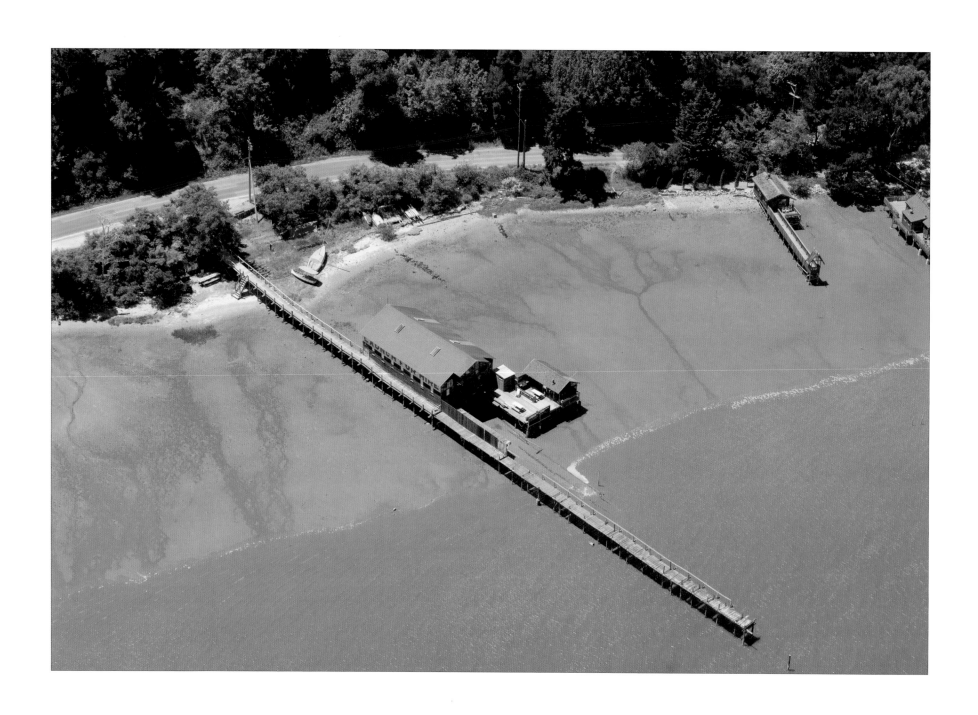

▲ "Launch for Hire," Tomales Bay
May 2006

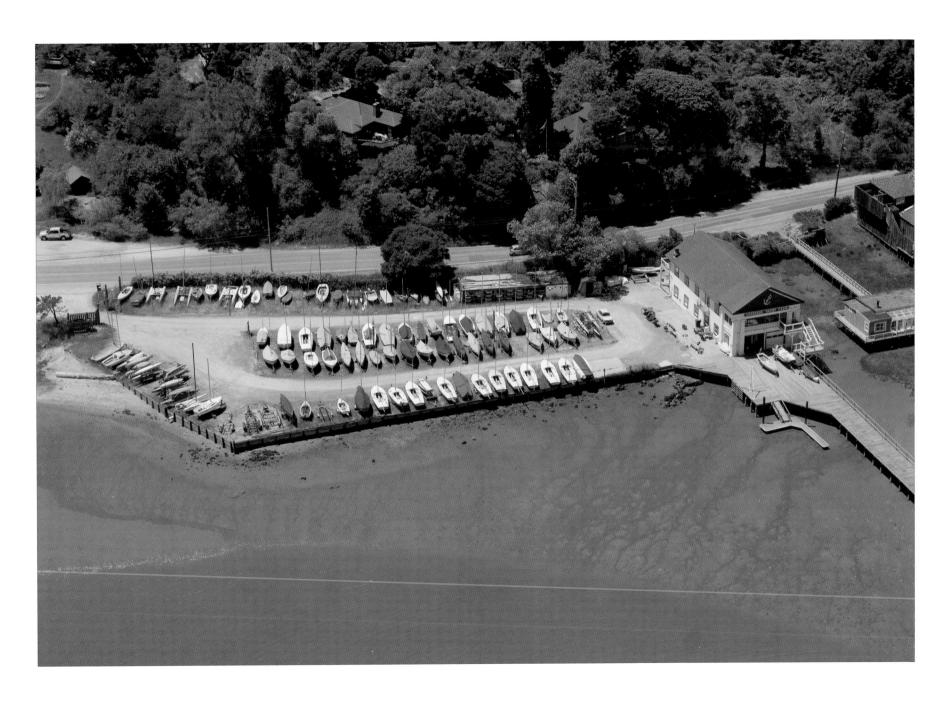

▲ The Inverness Yacht Club
May 2006

▶▶ The Inverness Yacht Club
May 2006

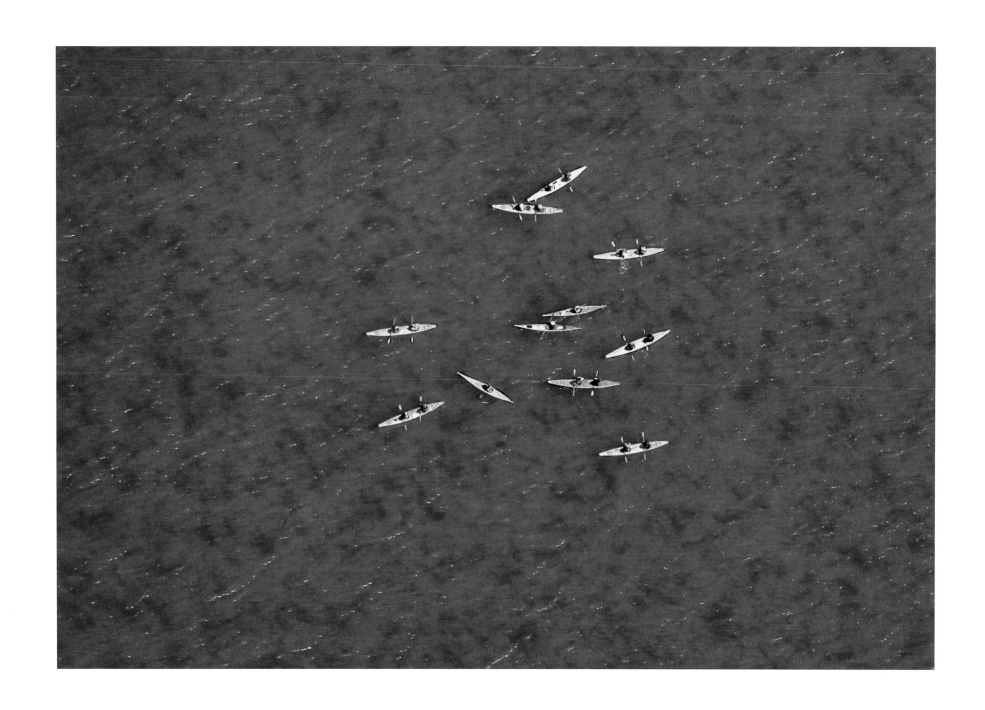

▲ Kayaks on Tomales Bay
June 2007

▶ Pelican Point
April 2006

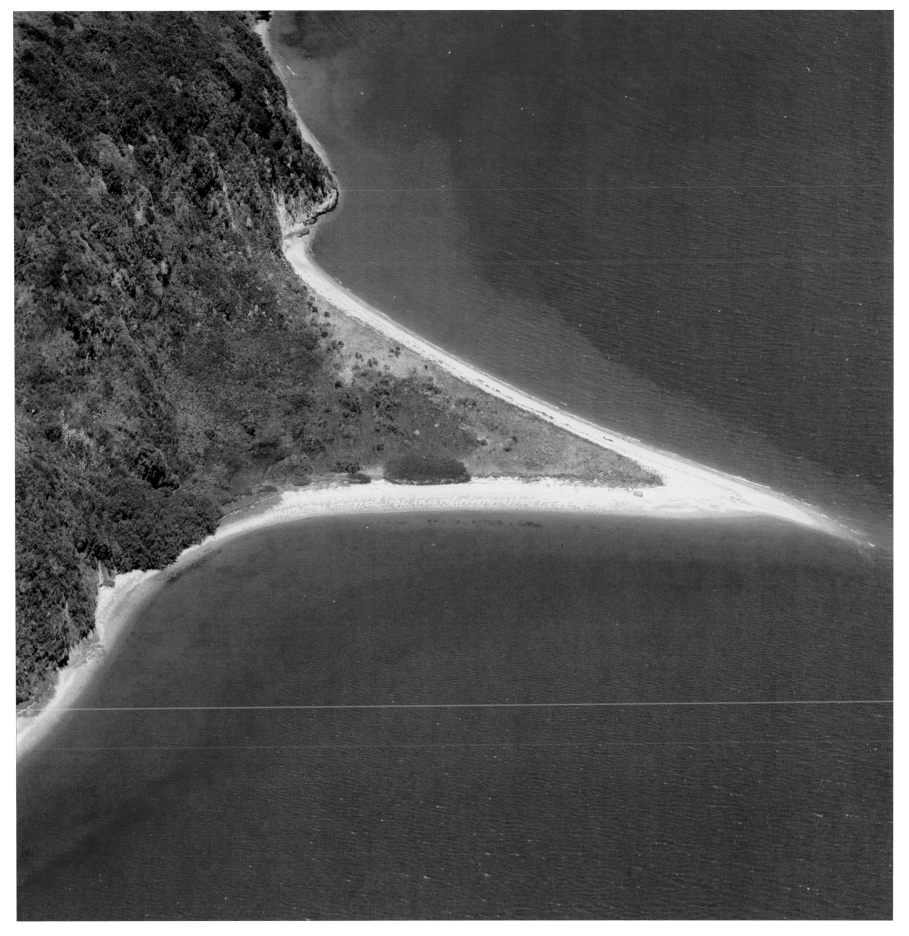

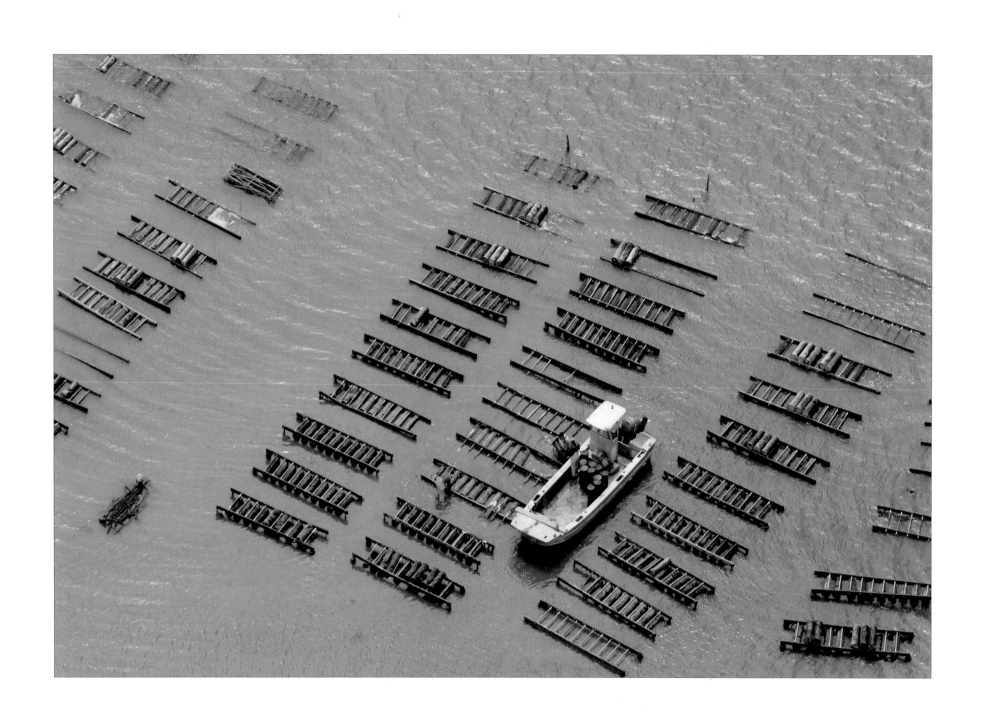

▲ Harvesting the Hog Island Oyster Beds
May 2006

▶ Hog Island Oyster Beds, Tomales Bay
May 2006

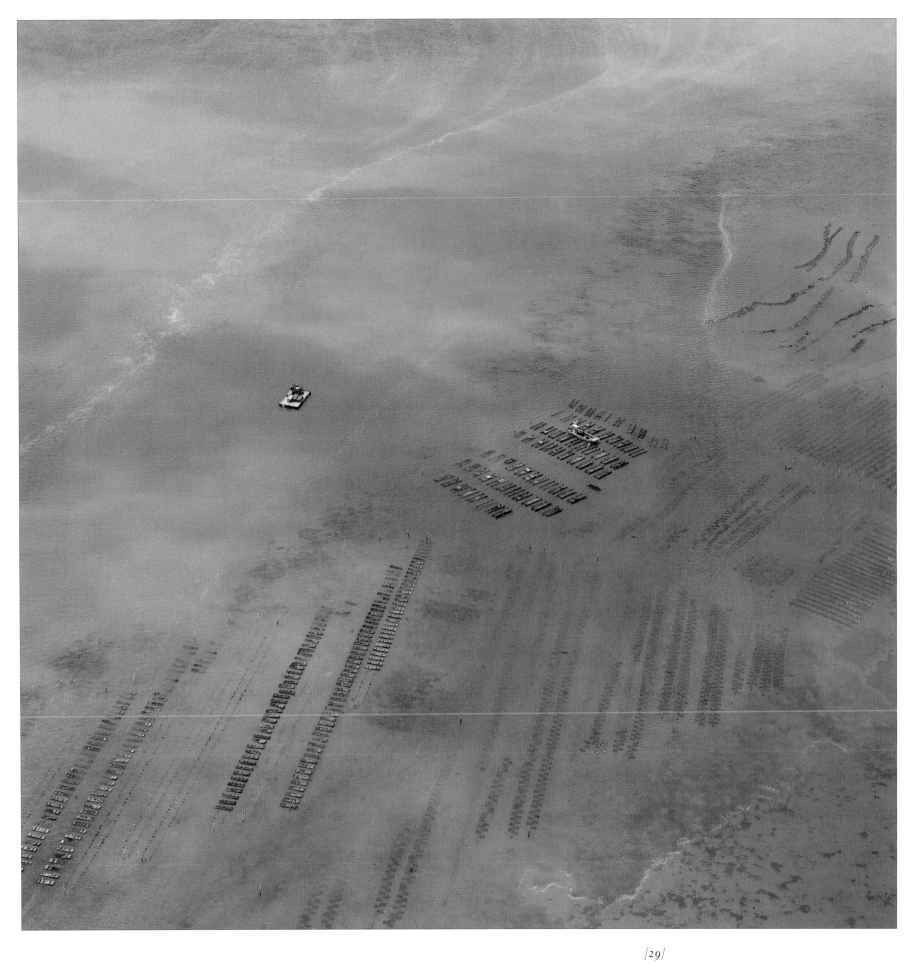

▲ OLD FISHING BOAT, MARSHALL
May 2006

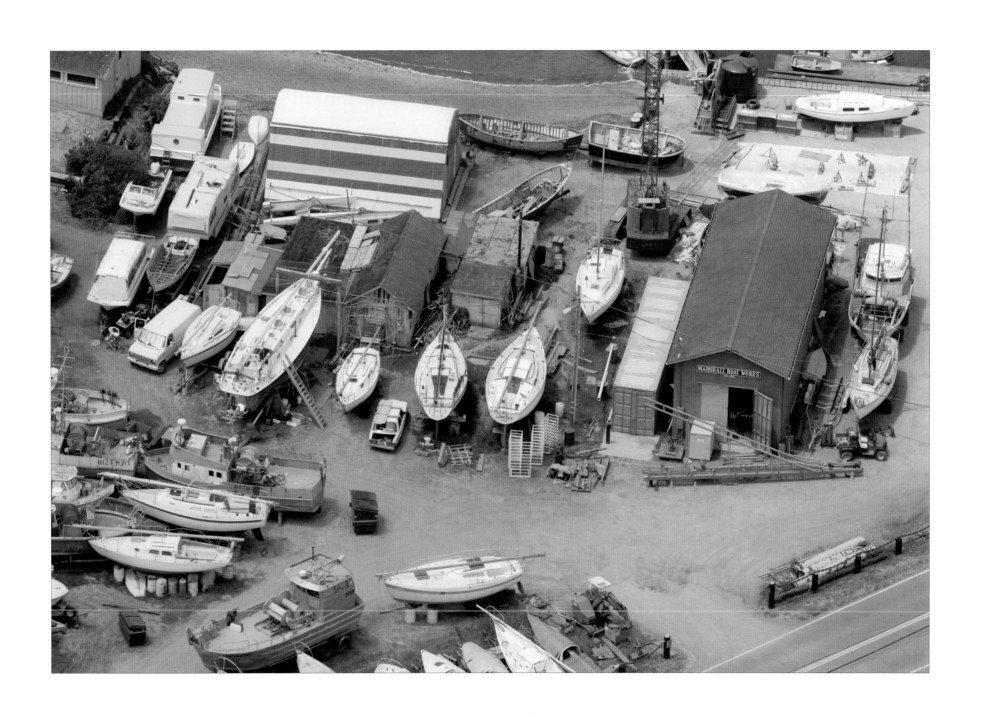

▲ Marshall Boat Works
May 2006

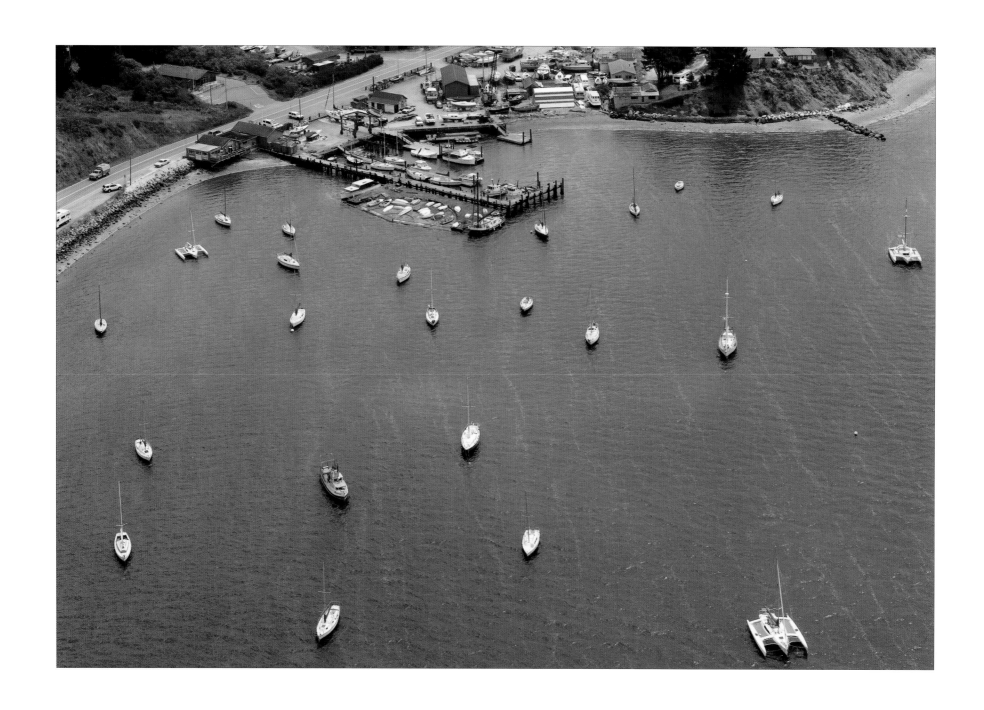

▲ MARSHALL HARBOR, TOMALES BAY
May 2006

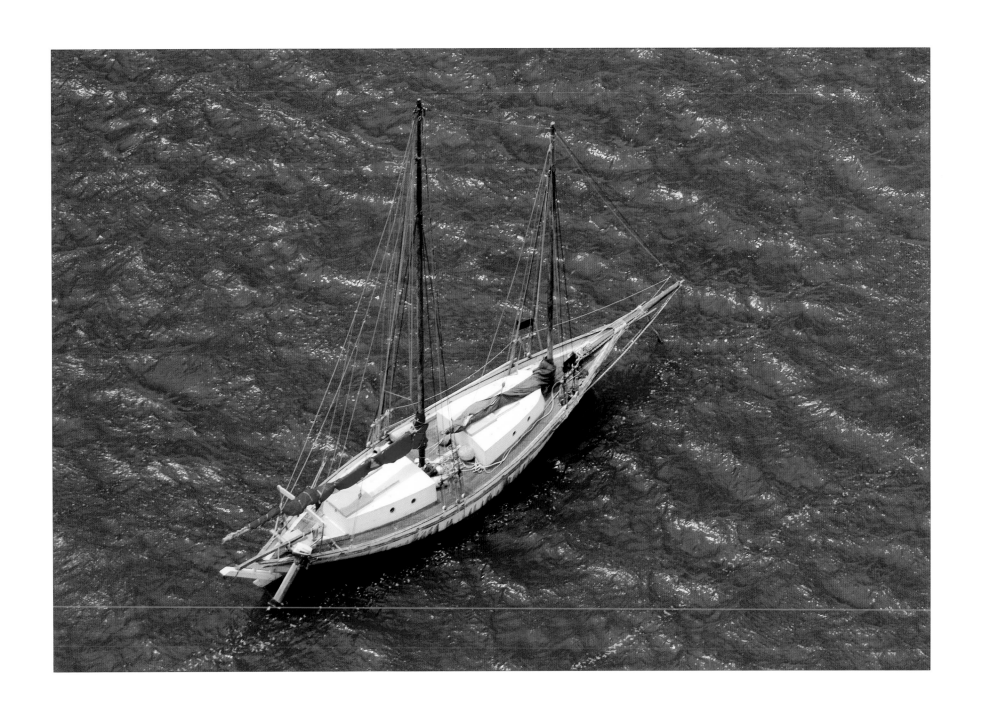

▲ Schooner Anchored Off Marshall
May 2006

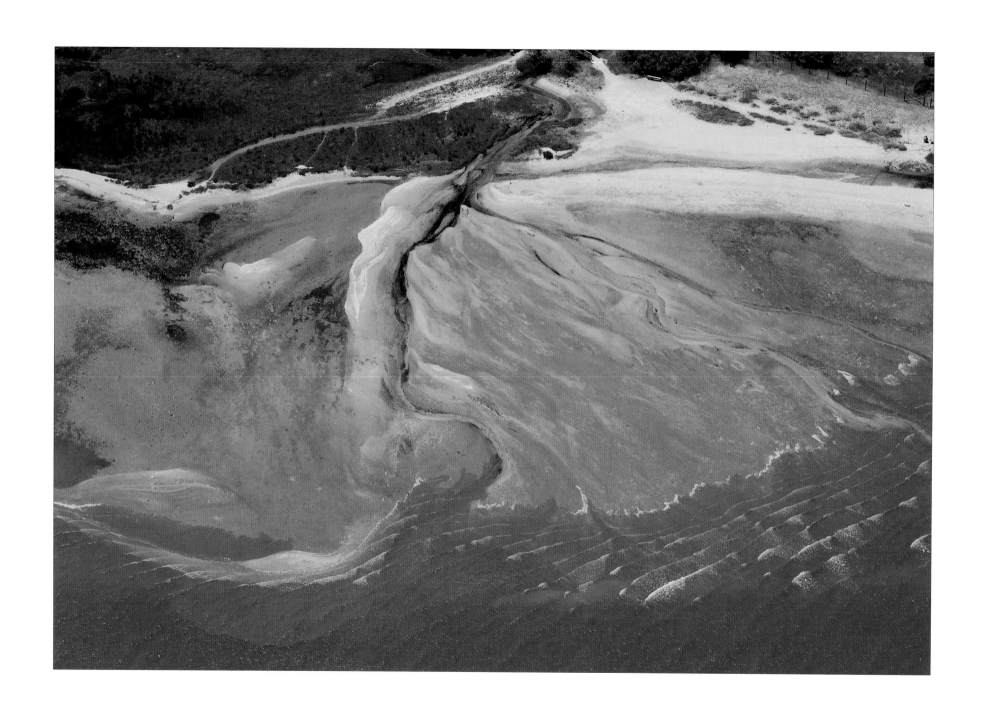

▲ Chicken Ranch Beach, Tomales Bay

May 2006

▶ Entrance to Tomales Bay,
Looking from Hog Island to Jenner

October 1995

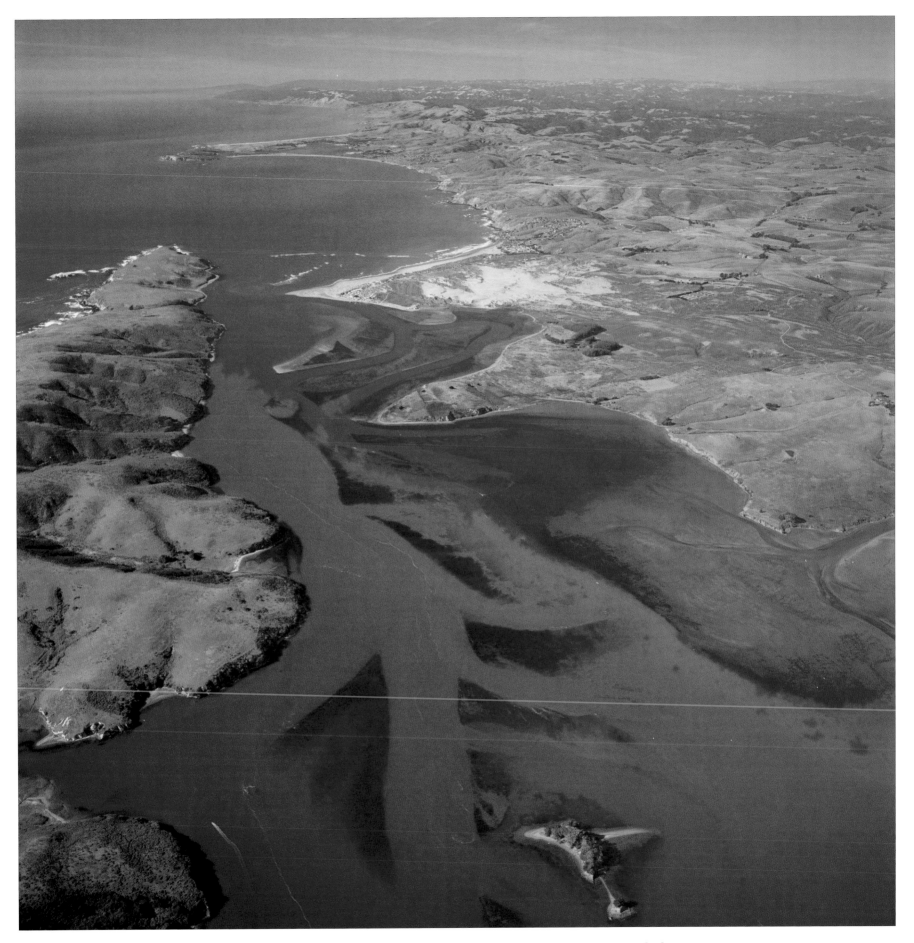

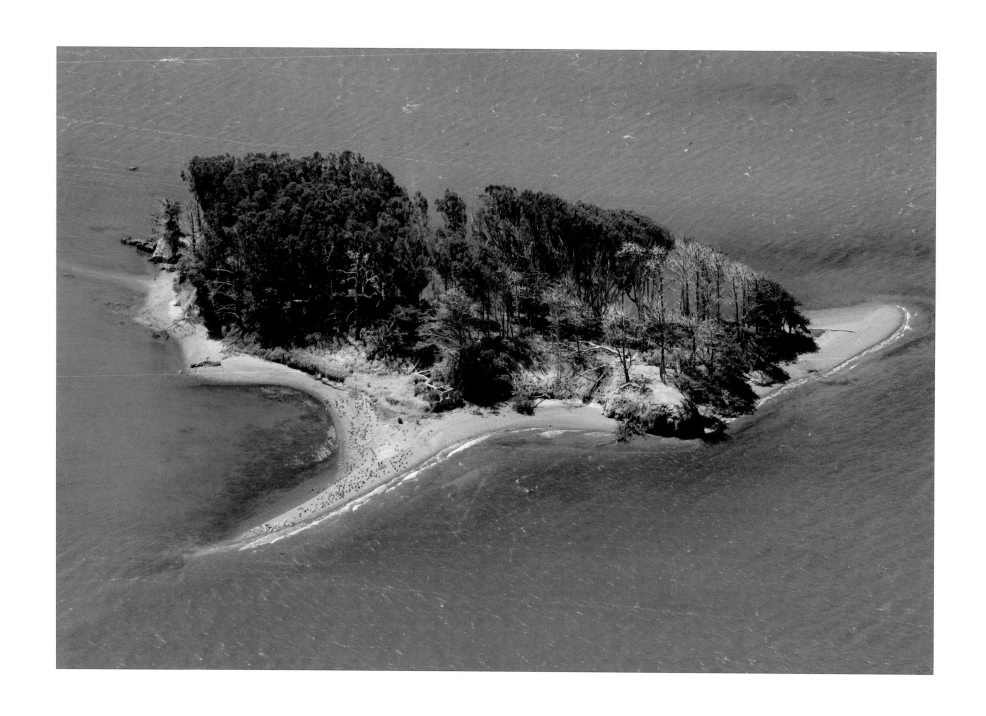

▲ Hog Island, Tomales Bay

May 2006

▶ Hog Island Detail:

Brown Pelicans, Gulls and Cormorants

May 2006

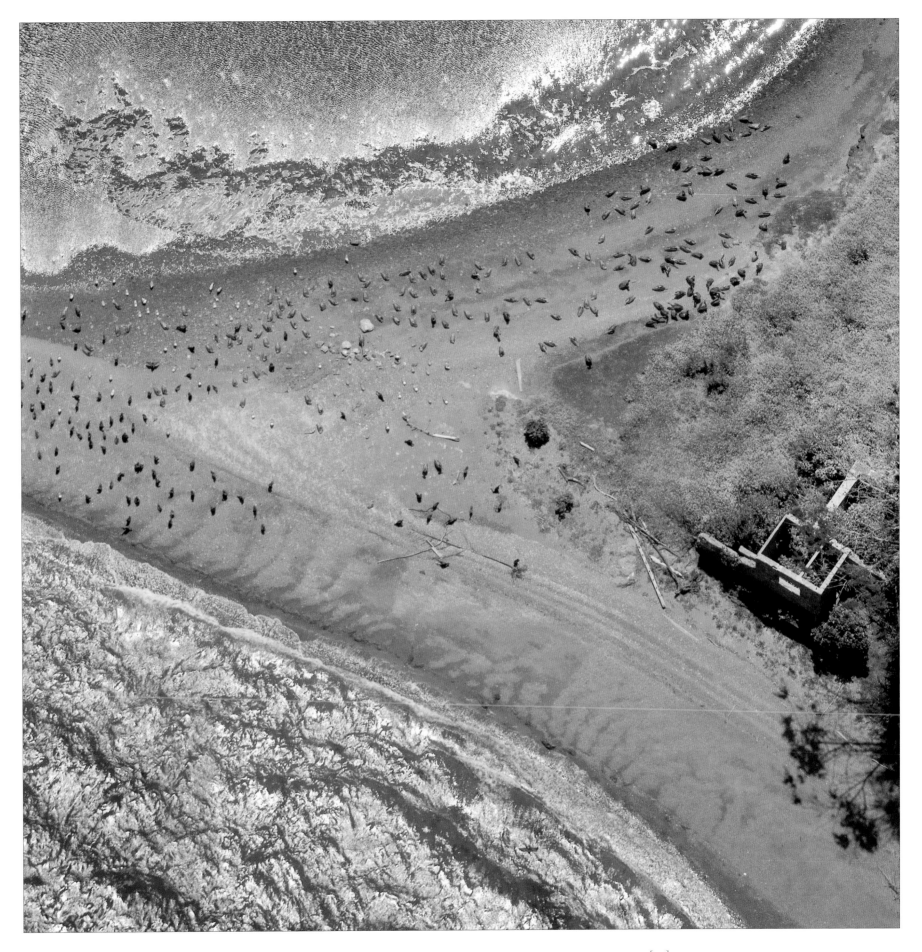

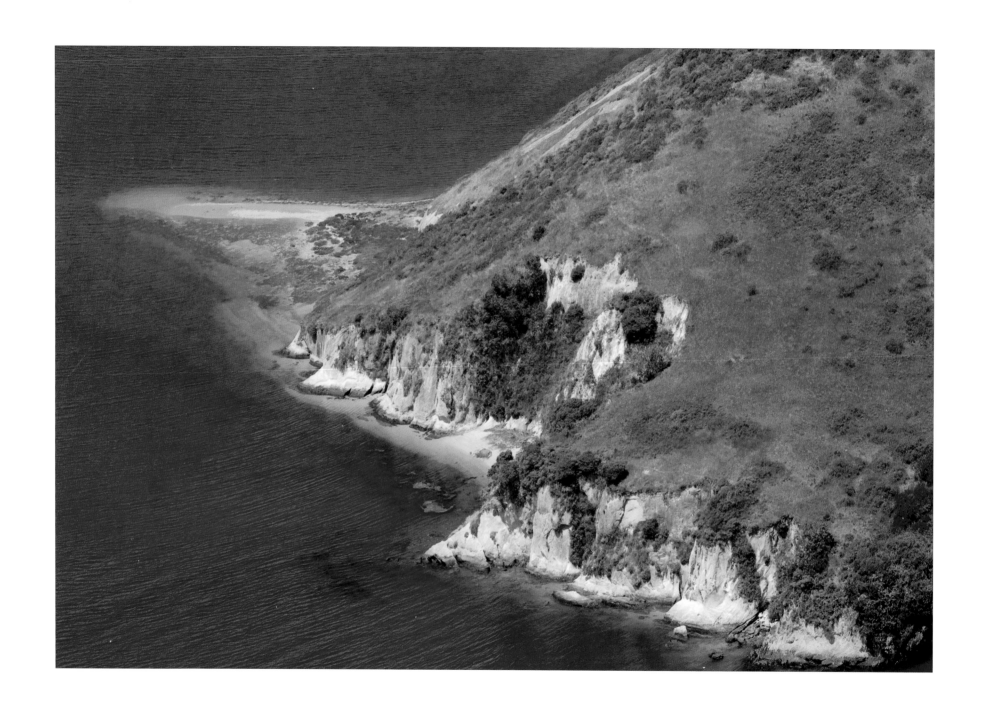

▲ WHITE CLIFFS AT WHITE GULCH, TOMALES BAY
June 2006

▶ ENTRANCE TO TOMALES BAY
July 1999

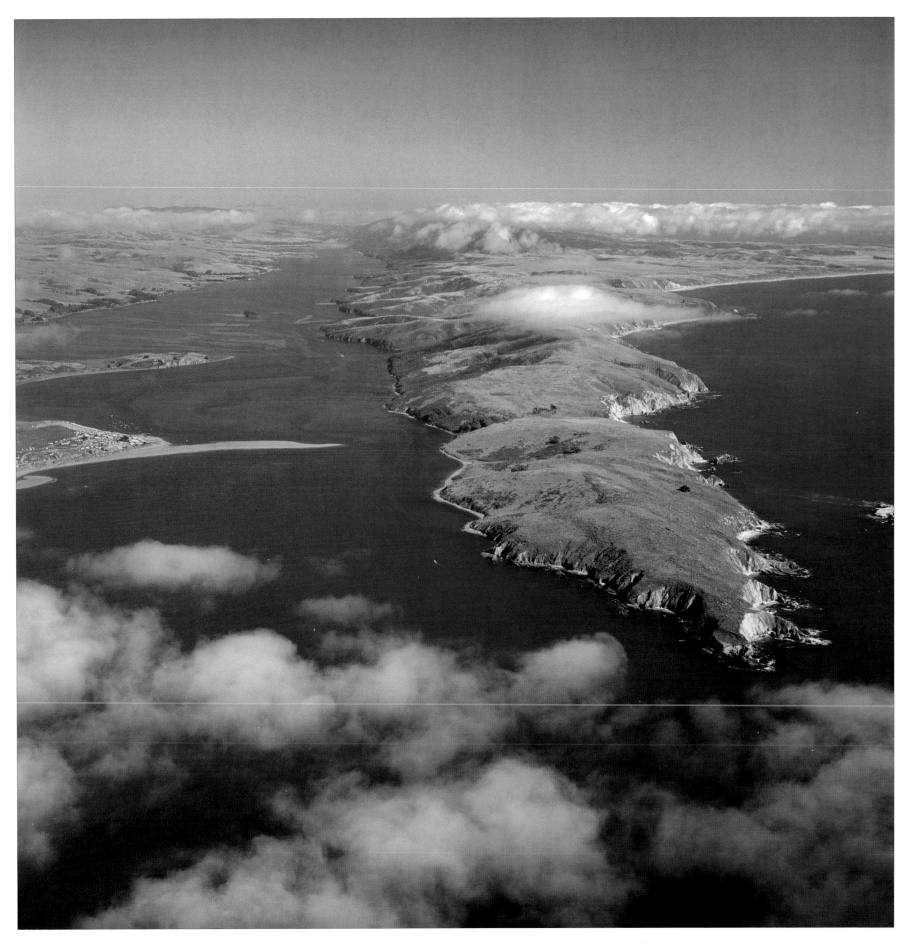

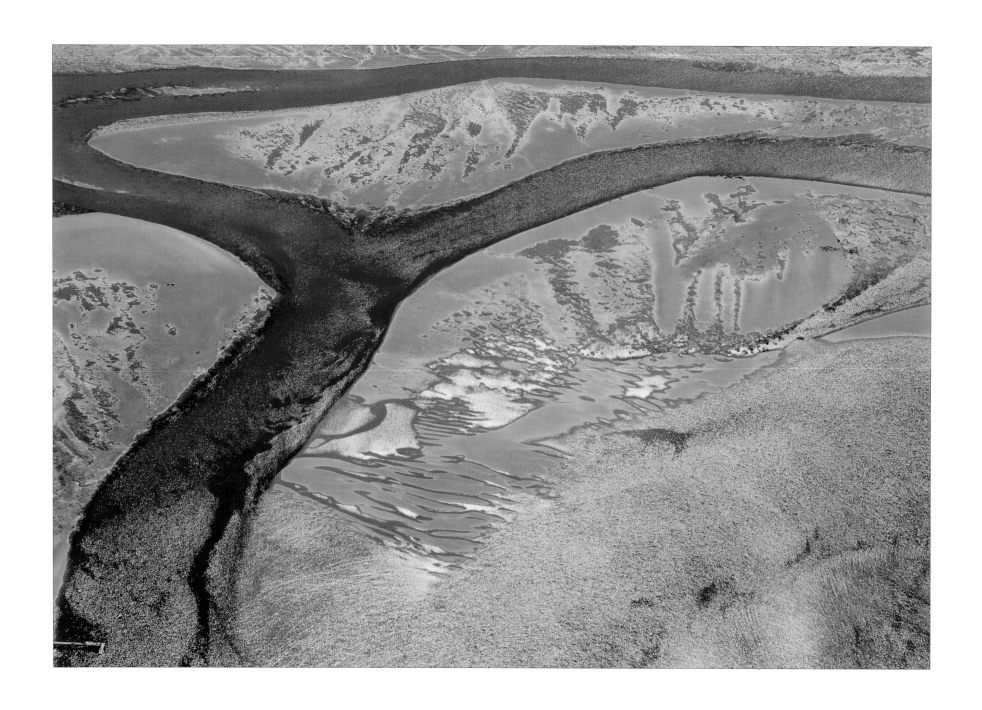

▲ Tomales Bay Tidal Channel
Near Dillon Beach
May 2007

▶ Dillon Beach and Tomales Bay
(San Francisco can be seen in the distance)
October 1995

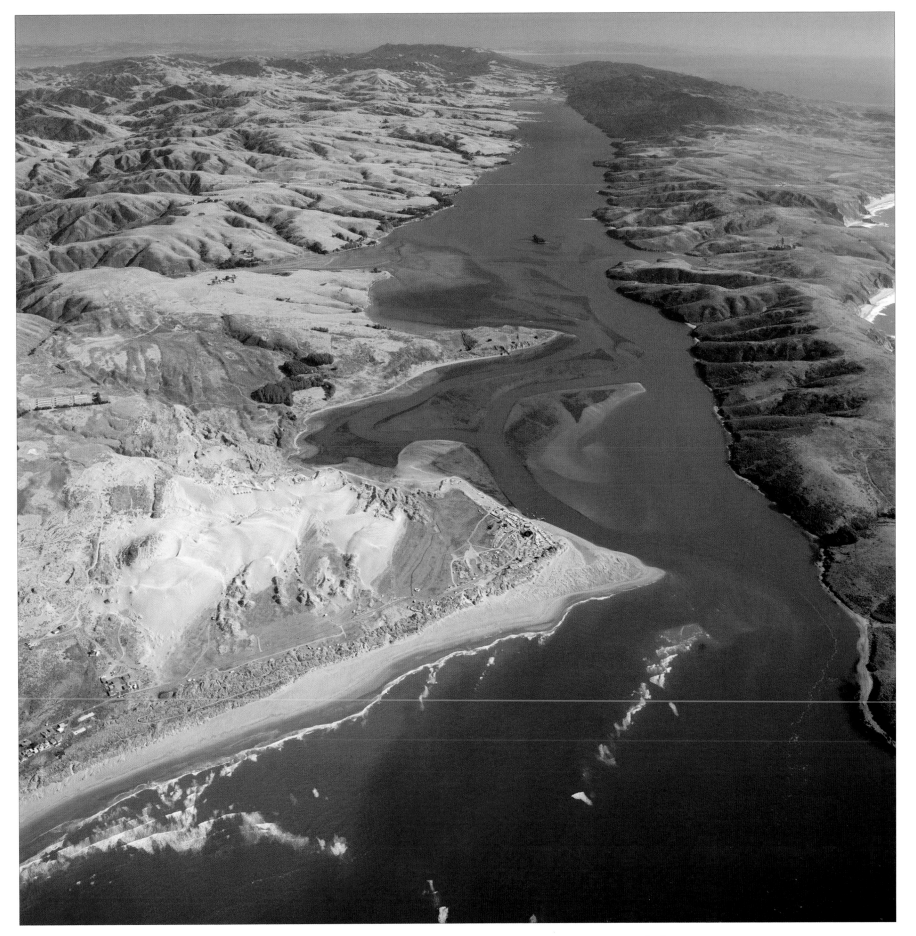

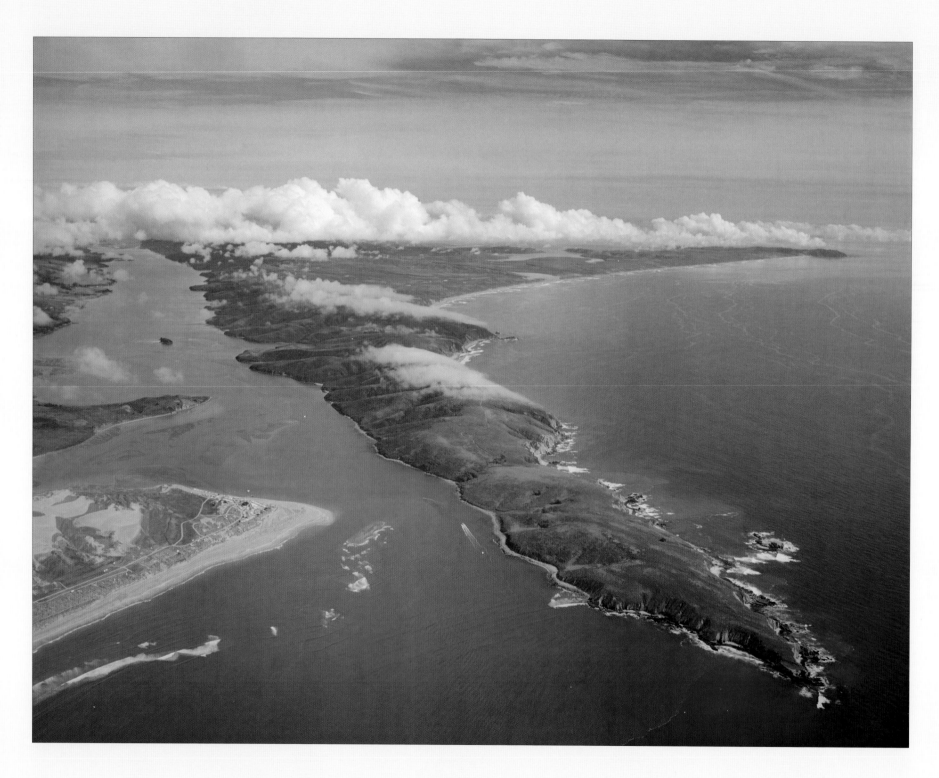

▲ TOMALES POINT WITH THE POINT REYES PENINSULA IN THE DISTANCE
March 1995

2. The Point Reyes Peninsula

A Landscape in Motion

FLYING OVER THE EASTERN EDGE OF THE POINT REYES PENINSULA, you can spot clues to why this 100-square mile landscape seems so out of place with the rest of the Northern California countryside. Here and there, along the rocky spine of the peninsula, from the long grassy tongue of Tomales Point to the forest-covered ridgeline running south along the Olema Valley, grey patches of ancient granite stand out from the green vegetation. Do not look for a counterpart to these rocks anywhere in the San Francisco area. The closest matching formation lies over 300 miles to the south, in the Tehachapi mountains near Los Angeles.

It's easy to find other evidence that Point Reyes is a block of rock in motion – an uplifted fragment of the Pacific Ocean floor grinding slowly northward against the continental margin of North America. Walk down the 300 steps to the Point Reyes Lighthouse and you'll descend through 50-million-year-old layers of sand and gravel deposited on top of the older granite. This is the debris of earthquake-triggered submarine landslides containing pebbles that match rocks found 100 miles south near present-day Monterey.

Fast-forward some 40 million years in geologic time by taking a stroll beneath the cream-colored cliffs that line the curving strand of Drakes Beach: The eroding layers of sand, silt and mudstone that occasionally come crashing down on unsuspecting sunbathers accumulated on the ocean floor just three-to-six million years ago. By that time, the bit of ocean crust that would become today's Point Reyes peninsula had been pushed much further northward along the San Andreas fault, and would soon emerge from the sea to be sculpted by the forces of wind, water and earthquakes.

Today, deep beneath our feet, rising currents of hot magma below the Earth's crust continue to power movement along the San Andreas fault. Slowly, invisibly, the Point Reyes peninsula is on the move, pushing northwest into the Pacific at about the same speed your fingernails are growing. Eventually the peninsula will break free of the North American mainland and become a true island. In 20 million years, it may crash into another crustal plate and disappear into a deep trench off the coast of Alaska. Or not. The past geologic wanderings of the peninsula have been complex and difficult to decipher, the future journey even more so. But one thing seems certain: In the geologic scale of time, our days onboard this traveling landscape will be over in less than a blink of the eye. Enjoy the ride while you can!

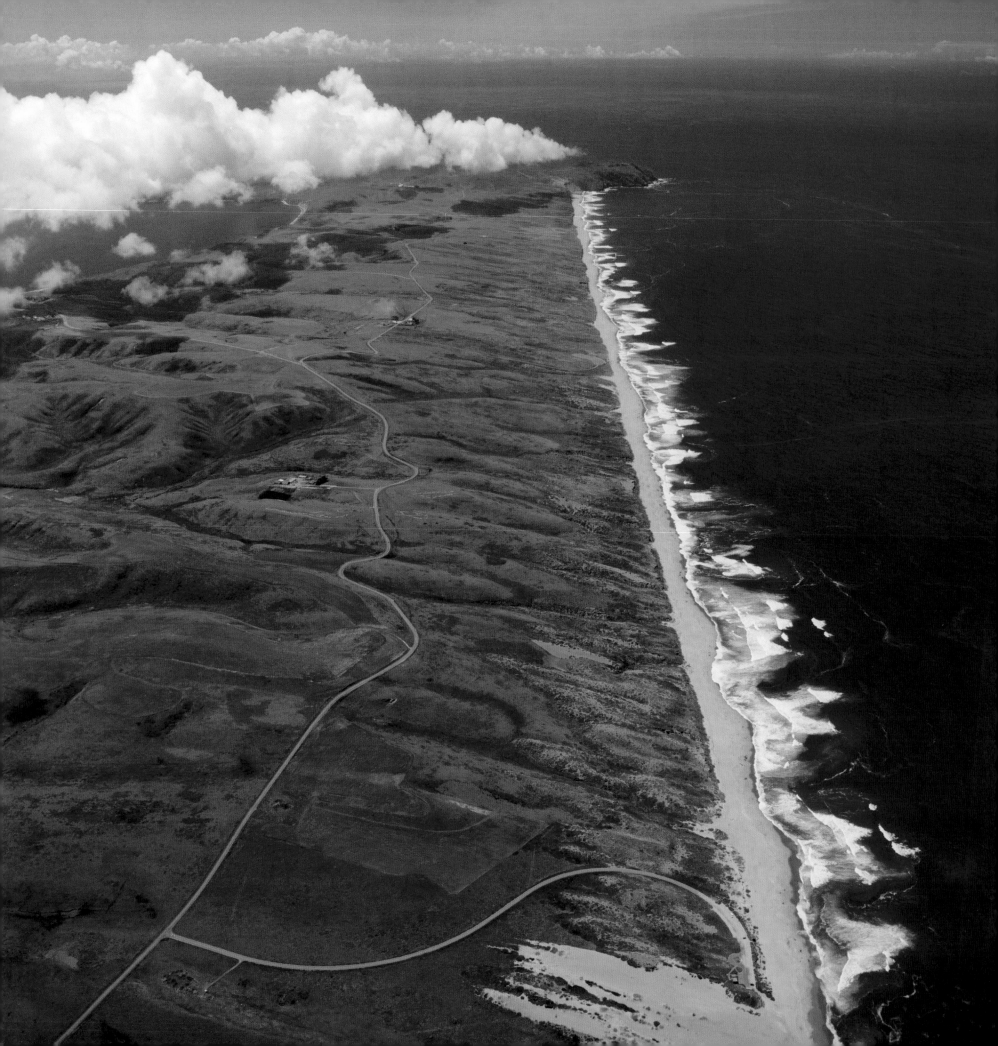

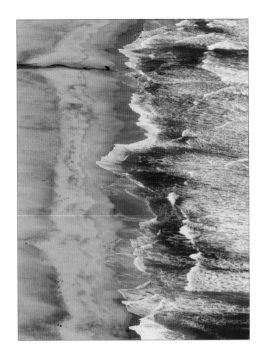

McClures Beach

Ocean Beaches

A Miles-long Panorama of Sand, Surf, Fog and Wind

IN WINTER, STORMS LINE UP across the Pacific as if waiting their turn to pound the northern shore of the peninsula with huge waves and gale force winds. In summer, the seacoast disappears for weeks at a time in what Sir Francis Drake's chaplain despised as, "thicke mists and most stinking fogs." Some days, however, the fog rolls back to sea and visitors are treated to the panoramic beauty of a sun-drenched, unobstructed and unspoiled strip of sand almost eleven miles long. This is also the time to explore the more intimate charm of the pocket beaches interspersed among the cliffs further north. Visitors to this shoreline share the sand with many wild inhabitants – elephant seals, harbor seals, snowy plovers and myriad other species – and are sometimes treated to glimpses of passing gray whales surfacing beyond the breakers.

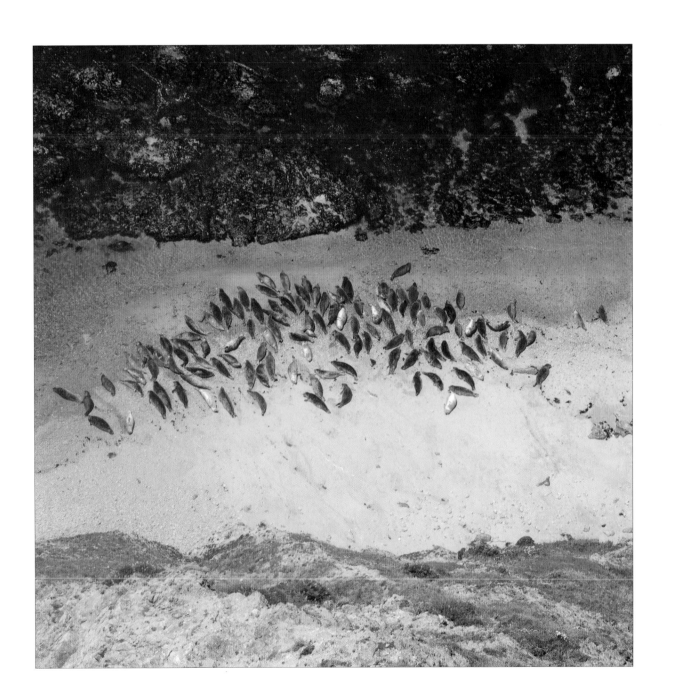

◀ POINT REYES BEACH (AKA "GREAT BEACH")
March 1996

▲ HARBOR SEALS, MCCLURES BEACH
June 2006

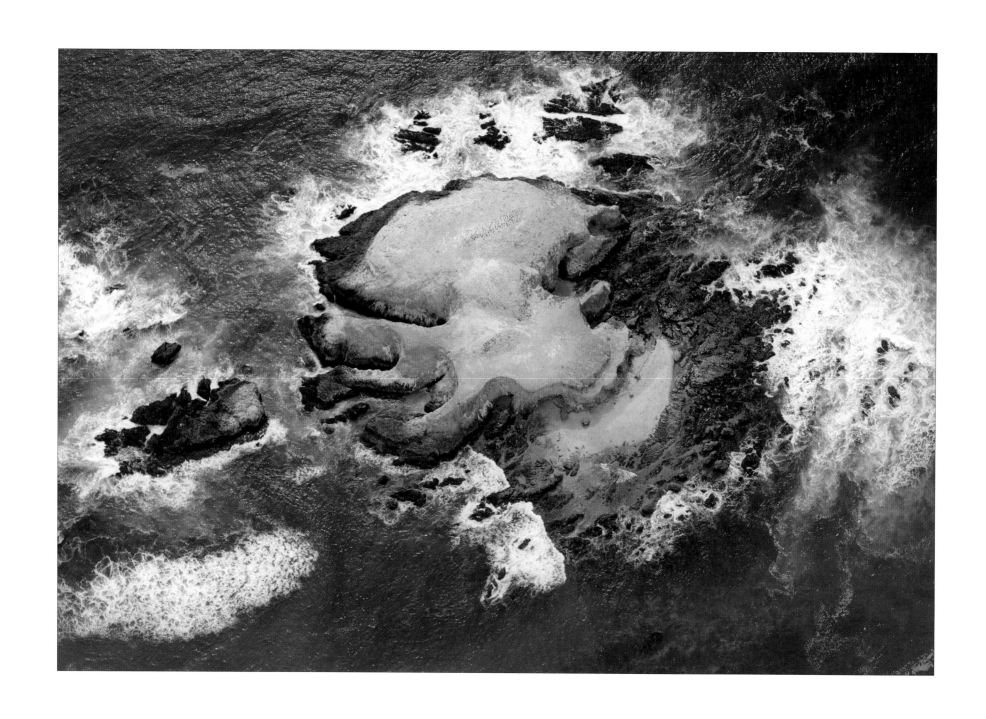

▲ Bird Rock
March 1995

▶ Tomales Point and Bird Rock
March 1995

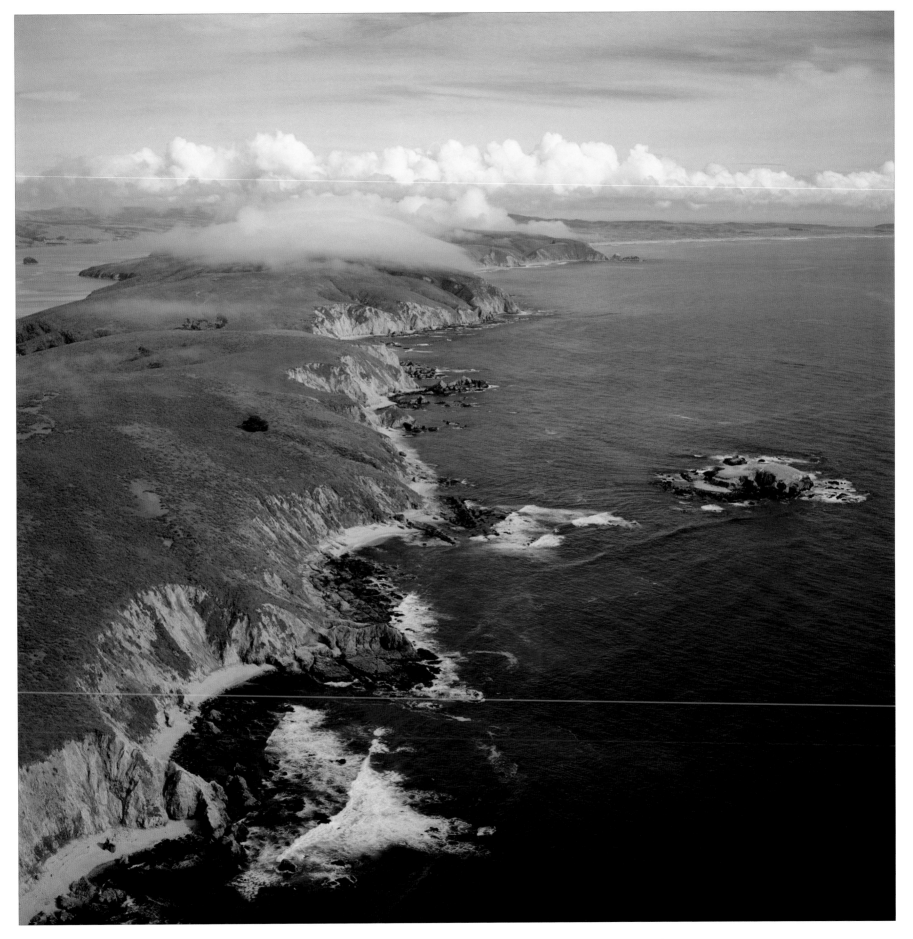

▲ Fog Clearing over the Great Beach
Looking toward Tomales Point
June 2006

▶ Point Reyes Beach
May 2006

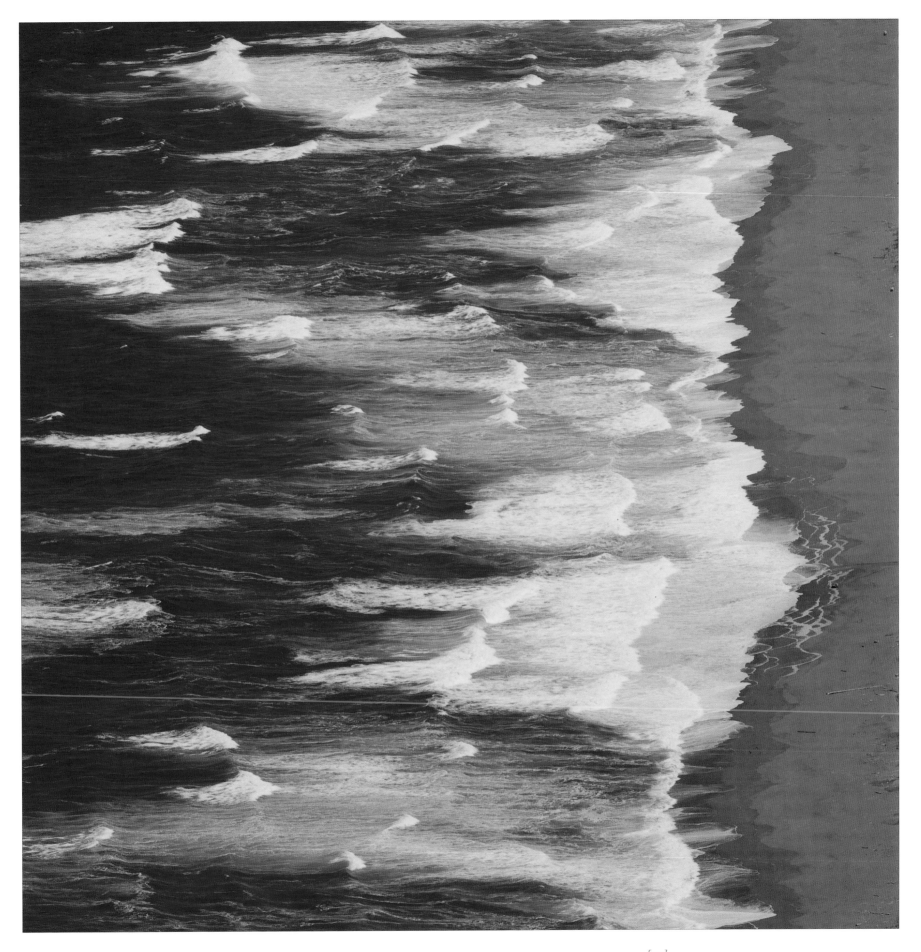

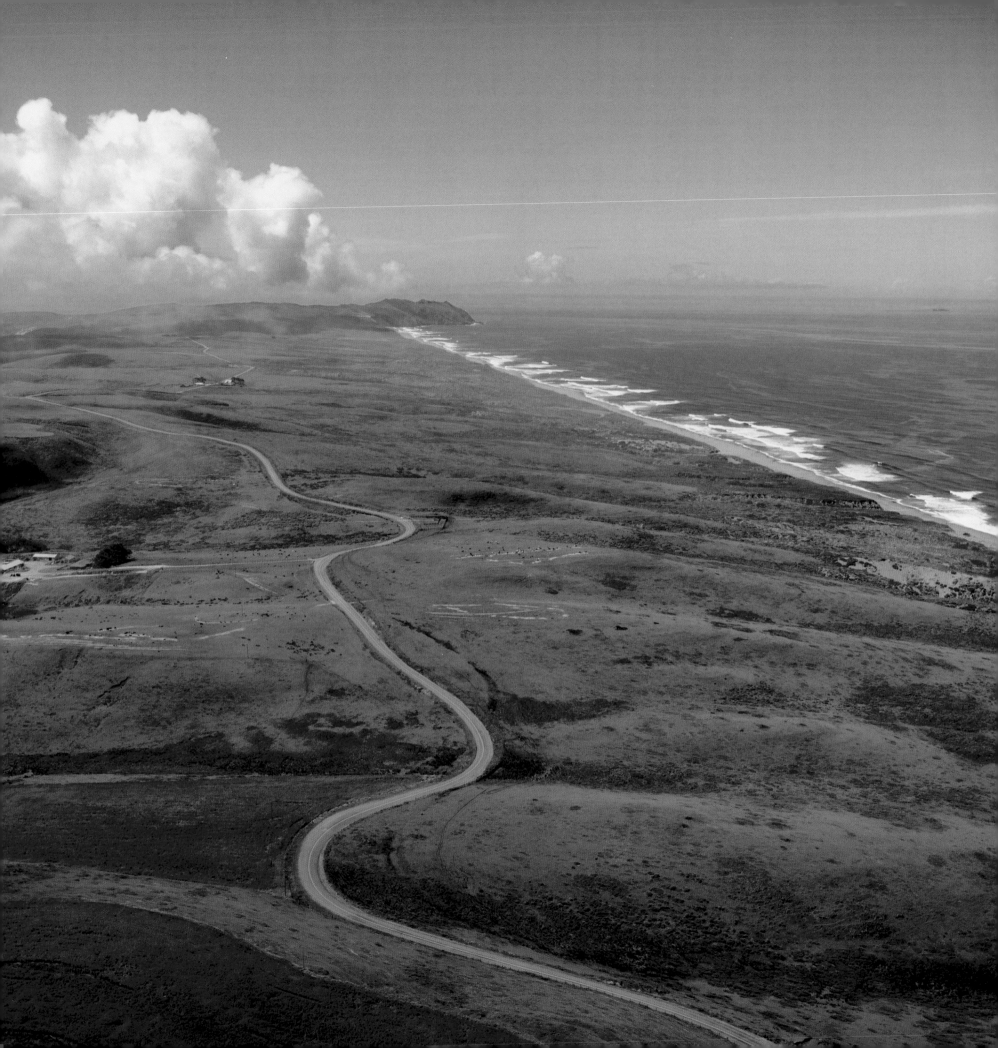

La Punta de Los Reyes
Point Reyes Lighthouse and Headlands

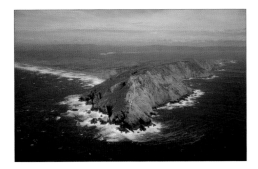

The Point Reyes Peninsula

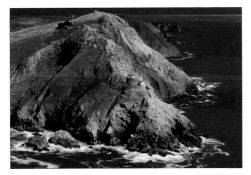

The Point Reyes Headland

THE JAGGED, STORM-BATTERED HEADLANDS at the western-most tip of the Point Reyes peninsula rise from the sea ten miles out from the California coast. Migrating whales must detour around this craggy obstacle, often passing directly below cliffs lined with delighted visitors. Dozens of passing ships have not been as fortunate, driven by storms or misguided in fog to their doom on the unforgiving rocks.

While investigating the first of Point Reyes' many shipwrecks – the *San Agustin* in 1595 – a Spanish explorer named the rocky promontory, *La Punta de Los Reyes*, after sailing past it on the feast day of "The Three Kings"(*"Los Tres Reyes"*). The lighthouse, built in 1870, reduced the number of ships lost each year along these cliffs; however groundings of sailboats and fishing vessels continue to this day.

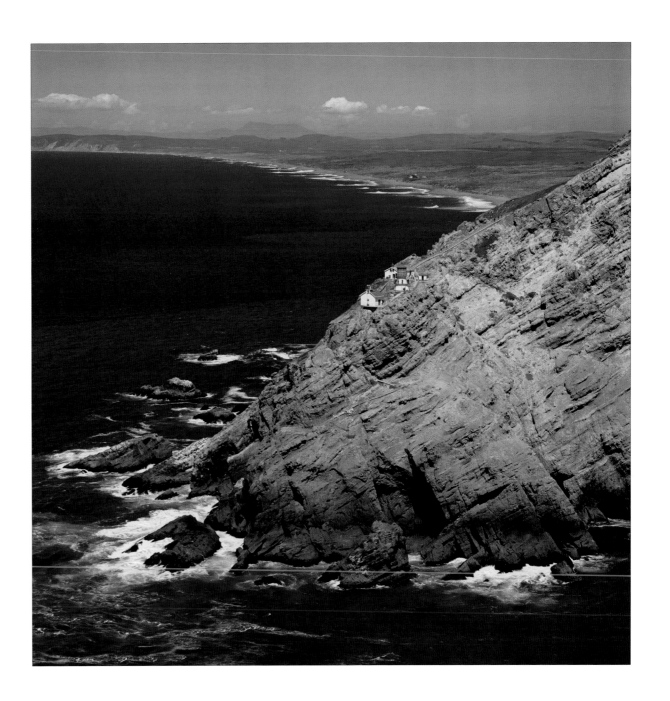

◀ ROAD TO THE POINT REYES LIGHTHOUSE
March 1995

▲ POINT REYES HEADLAND AND LIGHTHOUSE
January 2002

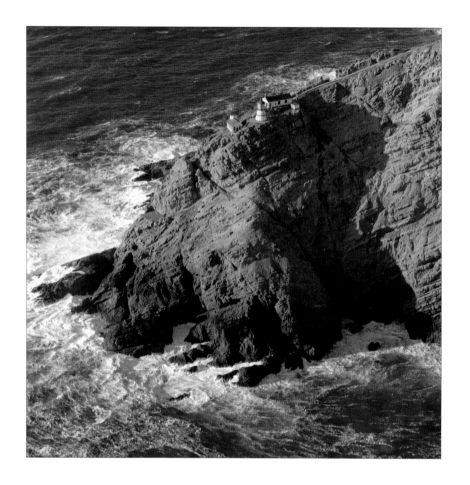

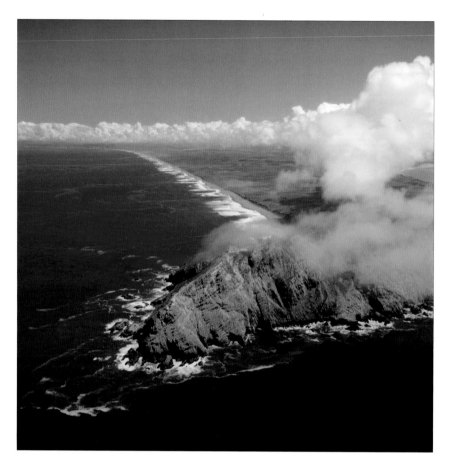

The Windiest Spot on the Pacific Coast

MANY A POINT REYES LIGHTHOUSE KEEPER cursed his misfortune to be isolated at one of the windiest and foggiest lightstations in the United States. Howling winds of winter storms, some recorded at over 130 miles per hour, forced lightkeepers to crawl up and down the 300-plus lighthouse steps on their hands and knees to avoid being blown over the adjacent precipice. In spring, unrelenting winds of 30 to 40 miles per hour pummeled the Point almost every day of the season. With summer, thick blankets of fog swallowed both sun and horizon, adding to the misery of a bone-chilling breeze.

Today these same conditions of incessant wind and fog confound modern visitors to the Lighthouse, many of whom arrive from sunnier inland areas woefully ill-dressed in shorts and T-shirts. Their feelings about the joys of Point Reyes weather may well mirror those of the early lightkeepers.

▲*l.* POINT REYES LIGHTHOUSE
November 1970

▲*r.* POINT REYES LIGHTHOUSE
February 1994

▶ CLEARING FOG,
POINT REYES PENINSULA
May 1995

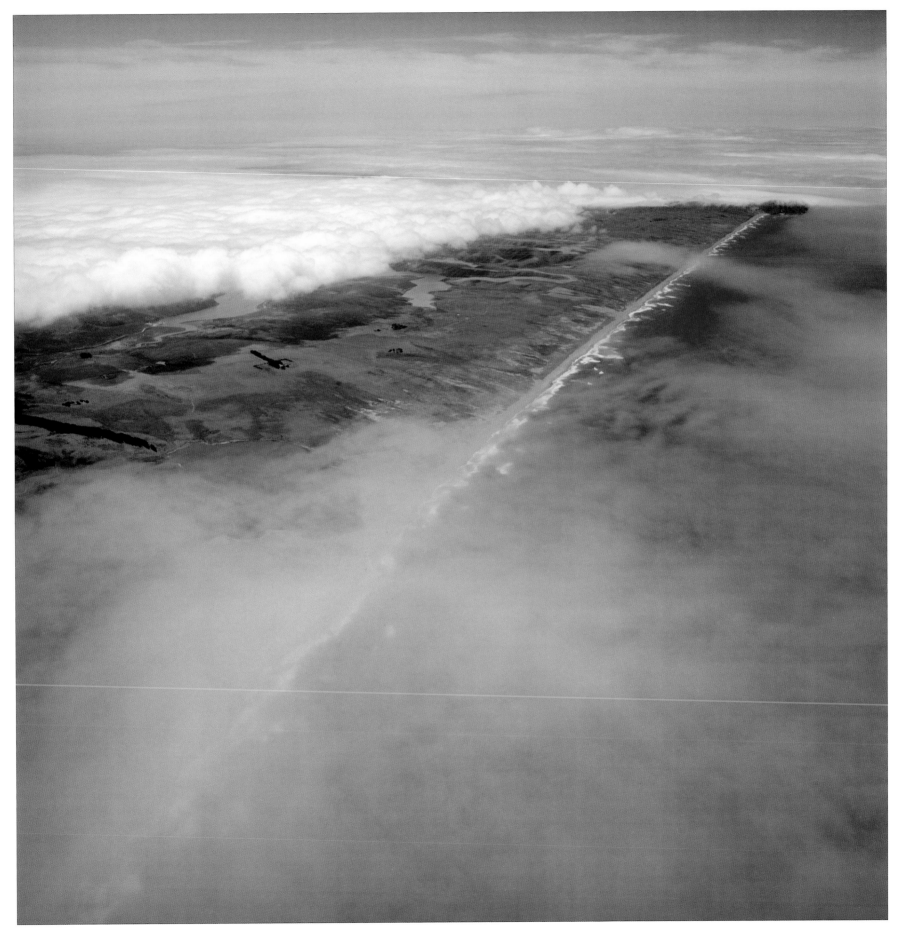

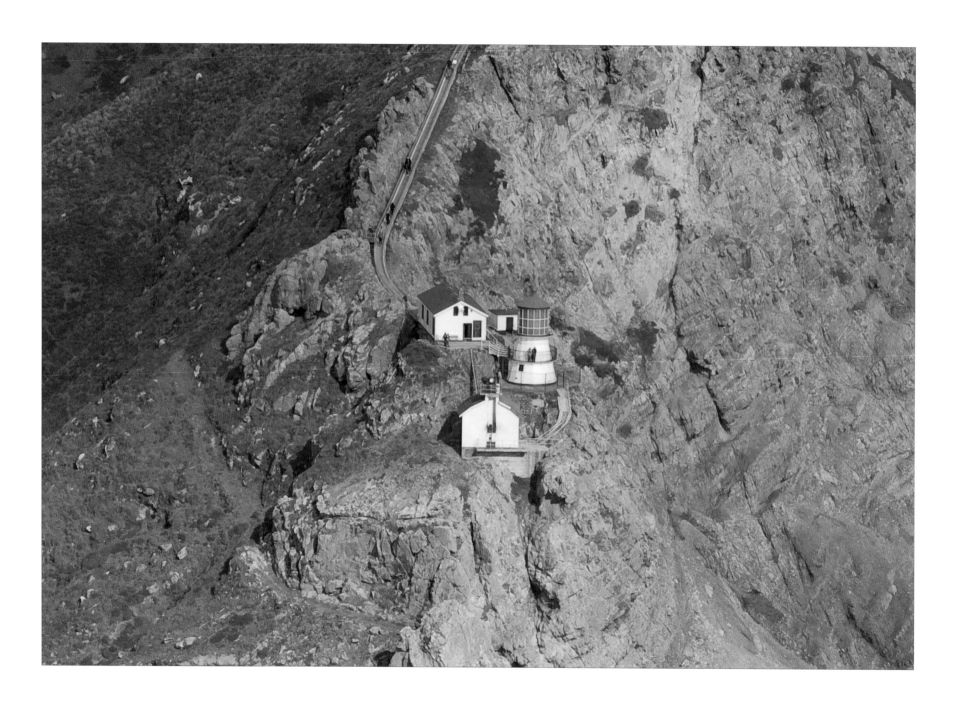

▶ The Point Reyes Headland and Lighthouse
February 1994

▲ Point Reyes Lighthouse
January 2006

▶▶ Lighthouse From Above
June 2006

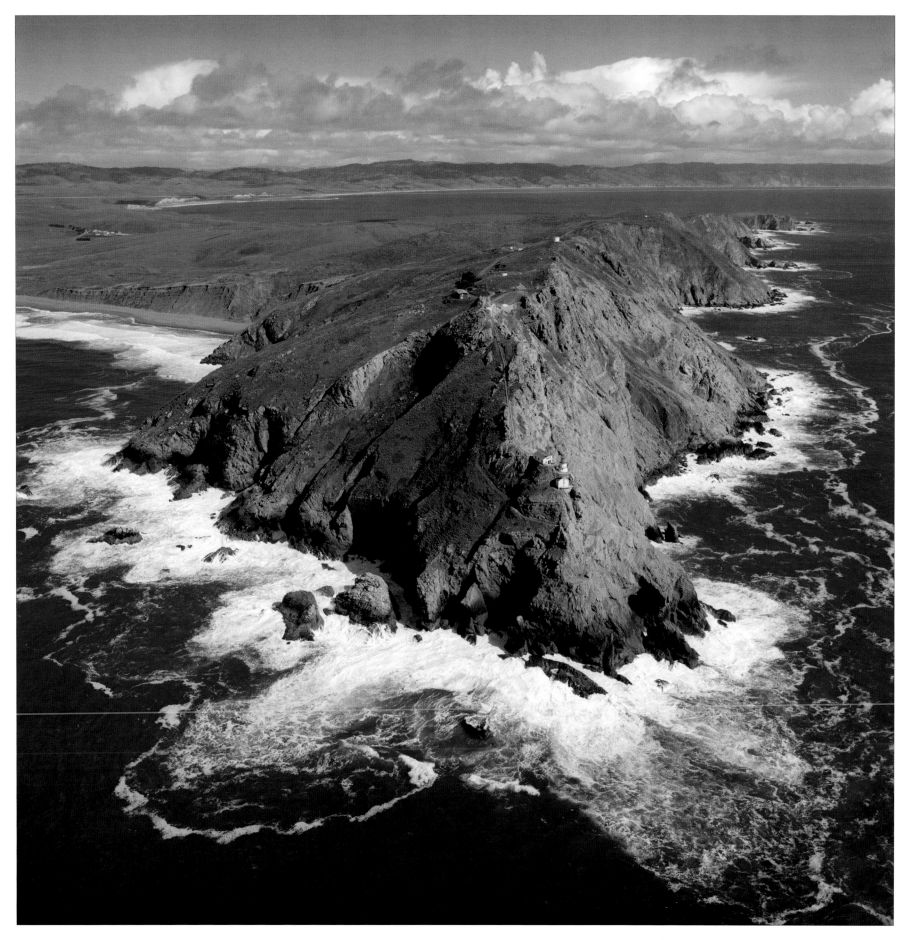

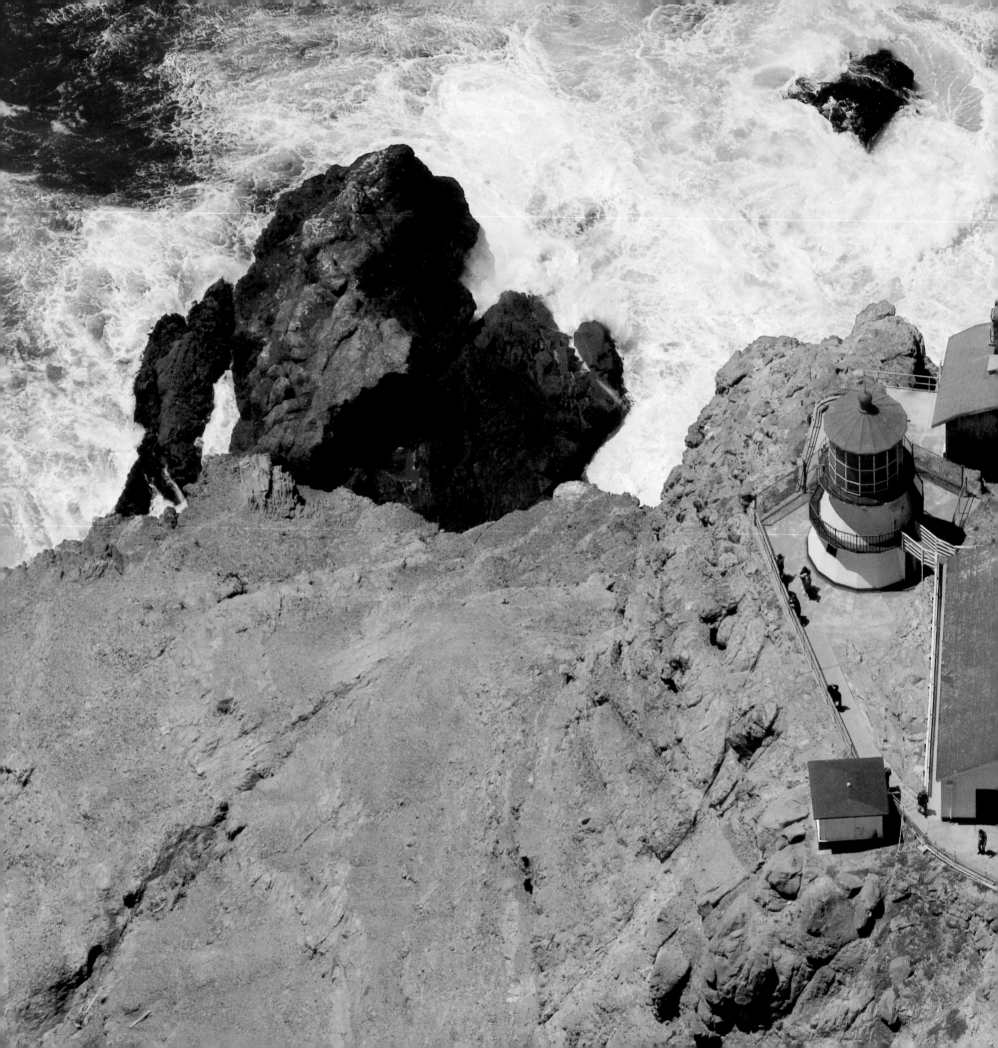

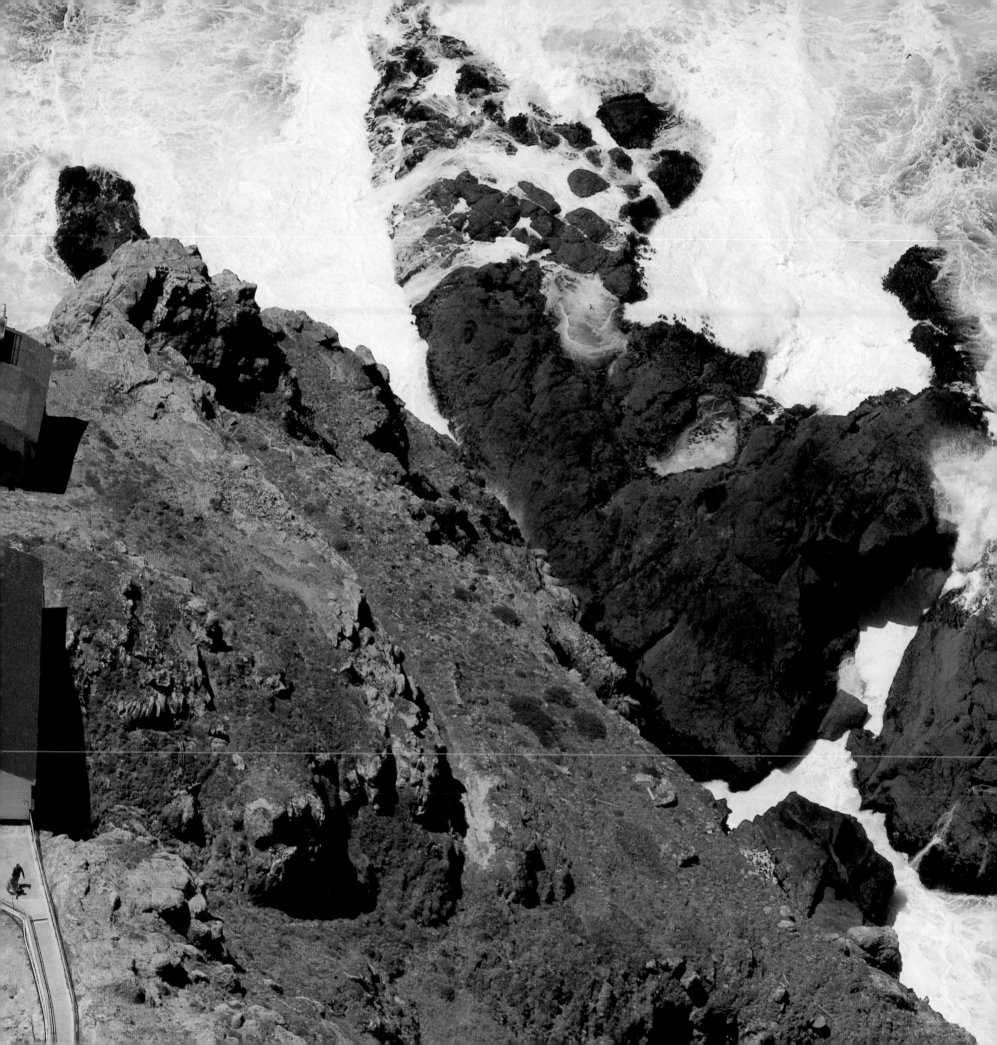

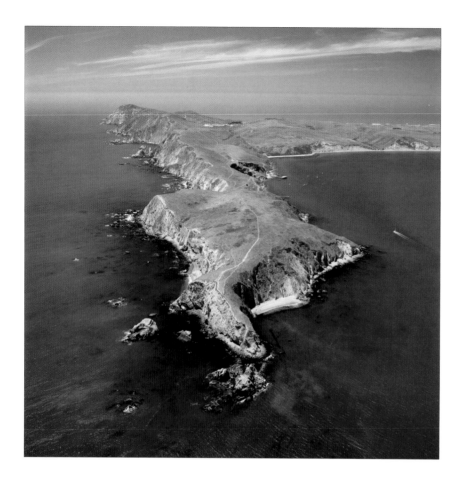

Exploring the Driest Landscape on the Peninsula

SOUTH OF THE LIGHTHOUSE, the hammer-shaped headlands of the Point Reyes peninsula fall away in steep cliffs at Chimney Rock. Aerial views of this windswept promontory taken at different times of the year illustrate the two-season nature of Point Reyes' Mediterranean-type climate: Summer drought; winter rain.

When Pacific storms return to the parched peninsula in late fall, most of the rain falls further inland on the higher ridges and in the valleys beyond. Inverness Ridge, for example, typically receives 36 inches of winter precipitation, the Lighthouse and Chimney Rock, just over 11 inches.

Fortunately, for spring hikers on the Chimney Rock trail, the low rainfall and unique Headlands geography combine to produce the peninsula's most spectacular display of coastal wildflowers. Those who visit at other times of the year "have to make do" with only a panorama of jagged cliffs, seal covered beaches, historic lifesaving buildings and the long curving coastline of Drakes Bay.

▲ *l.* SUMMER
August 1994

▲ *r.* WINTER
January 2002

▶ SPRING
April 1995

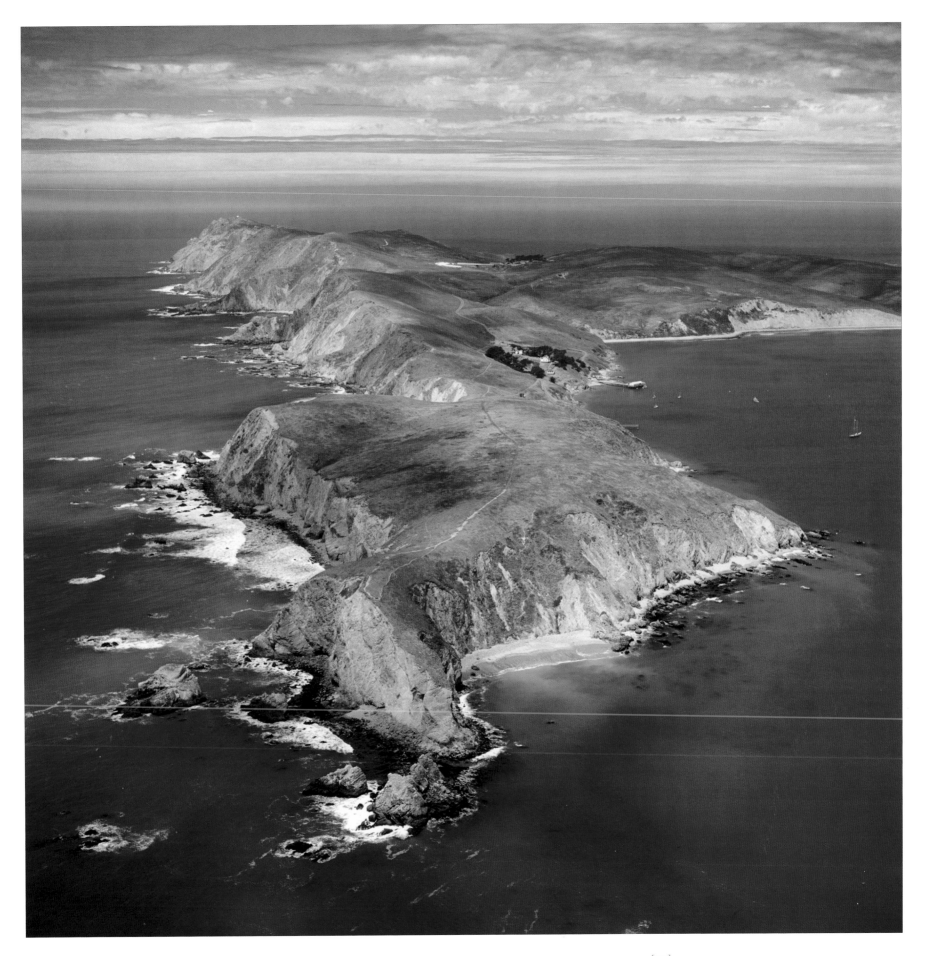

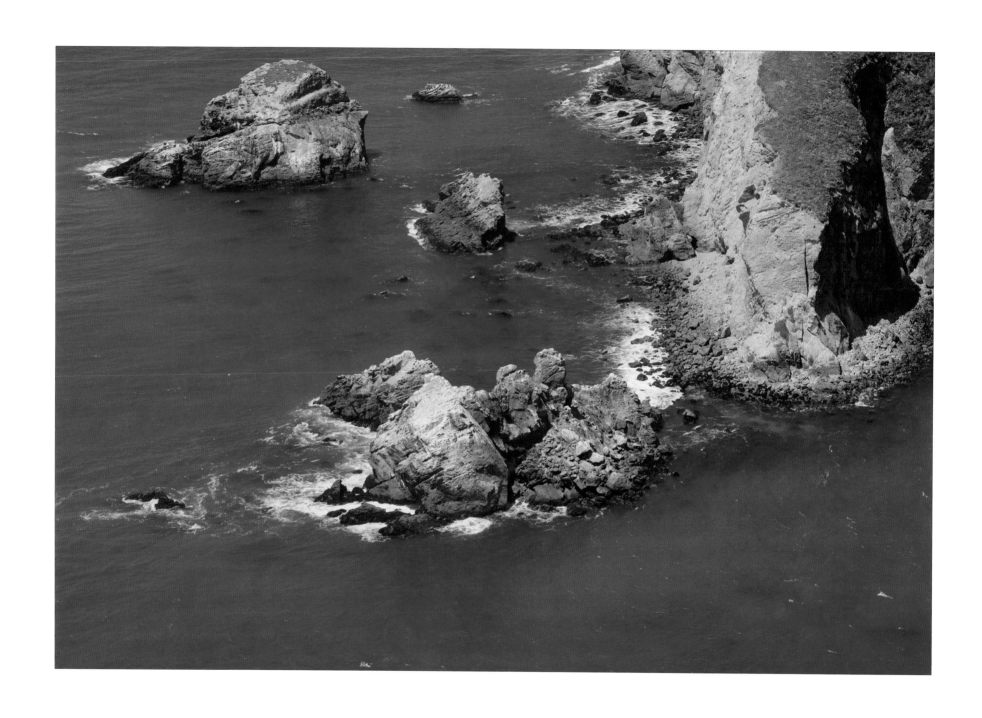

▲ Chimney Rock

May 2006

▶ Elephant Seals, Drakes Beach

May 2006

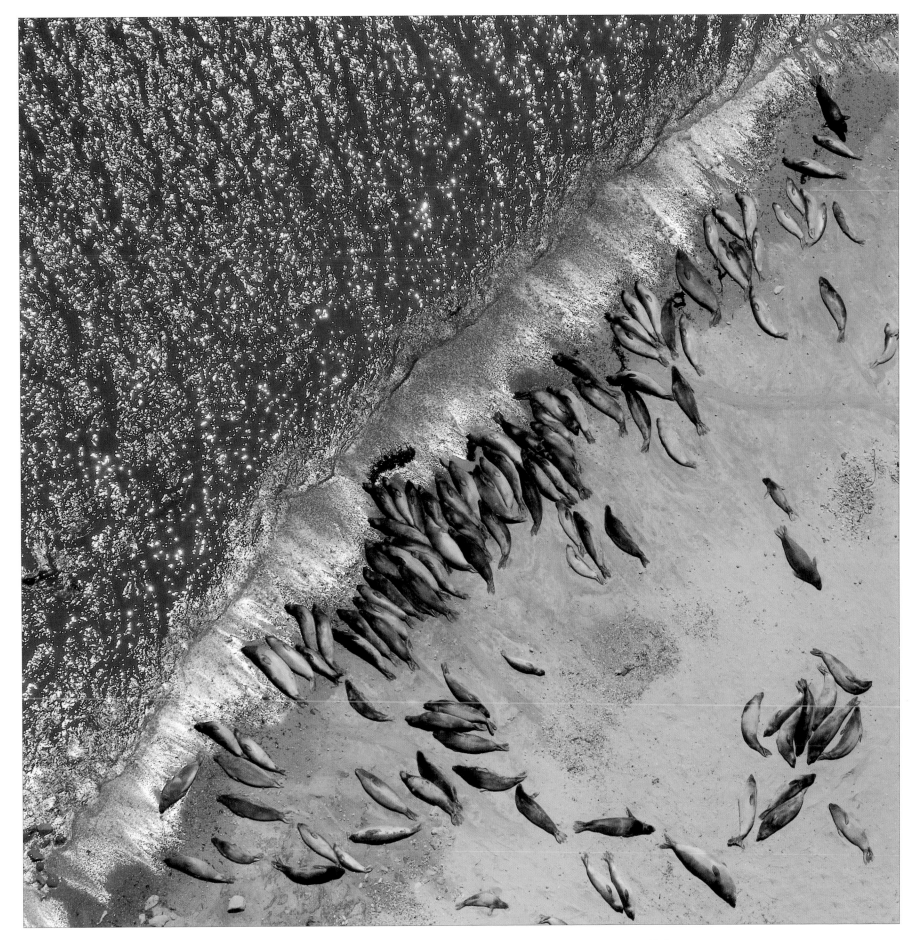

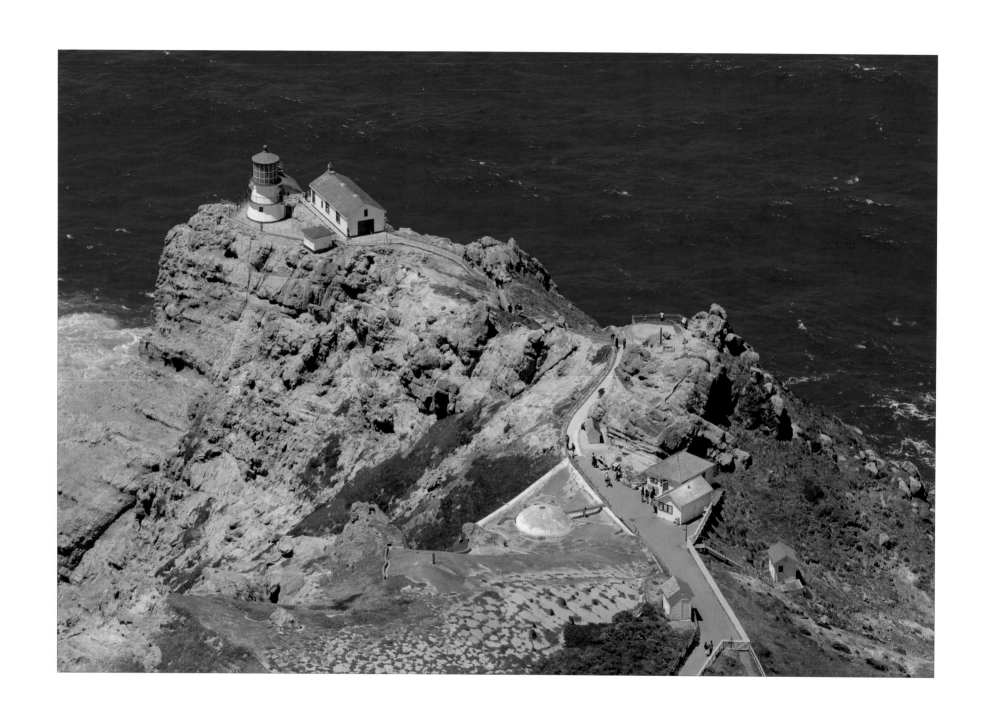

▲ The Visitor Center and Lighthouse
May 2006

▶ The Lifeboat Station, Drakes Bay
May 2006

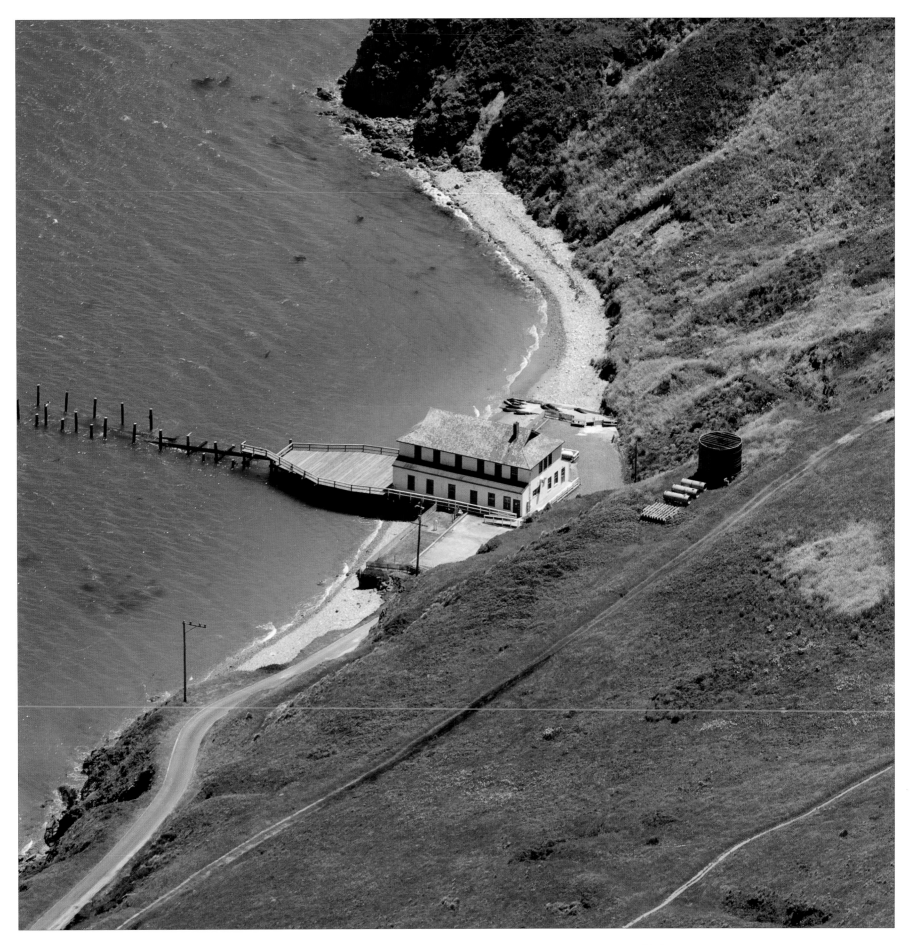

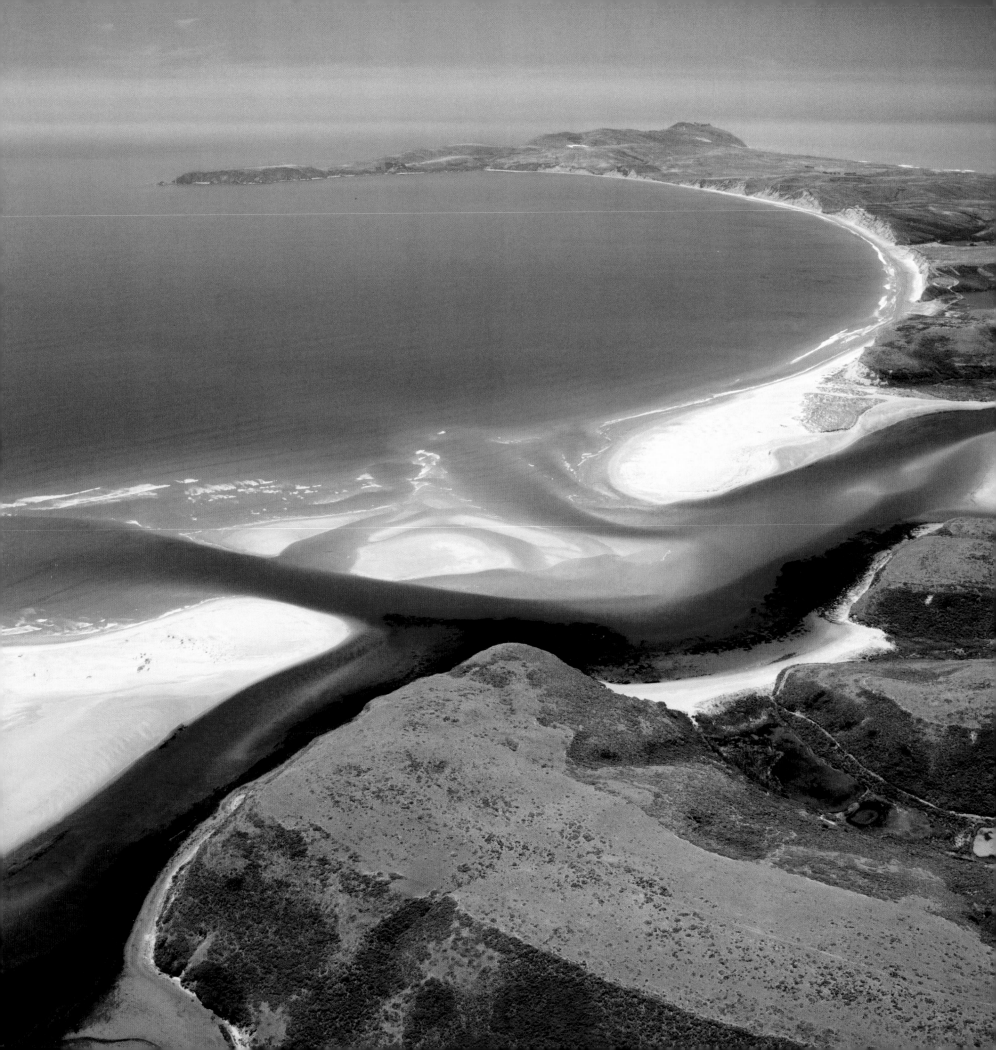

Drakes Estero at High and Low Tide

Drakes Bay and the Esteros

Sheltered Haul-out for Weary Ocean Travelers

PROTECTED FROM NORTHWESTERLY WINDS by the Point Reyes headlands and a curving line of white cliffs, the beaches and esteros of Drakes Bay have long offered refuge to Pacific voyagers.

Some still enter the bay under sail, in the manner of English privateer Francis Drake who, most historians believe, likely astonished local Coast Miwok Indians by careening his leaky galleon onto the sands of the estero bearing his name in 1579. The vast majority of those seeking a safe haul-out here, however, arrive not by gliding over the waves, but under them. Every day, when the moon's gravity pulls the ocean back from the sandbars of Drakes Estero, hundreds of harbor seals wiggle their way ashore for a warming rest. In winter, other flippered visitors arrive – elephant seals hauling out on North Drakes Beach after a migration of thousands of miles.

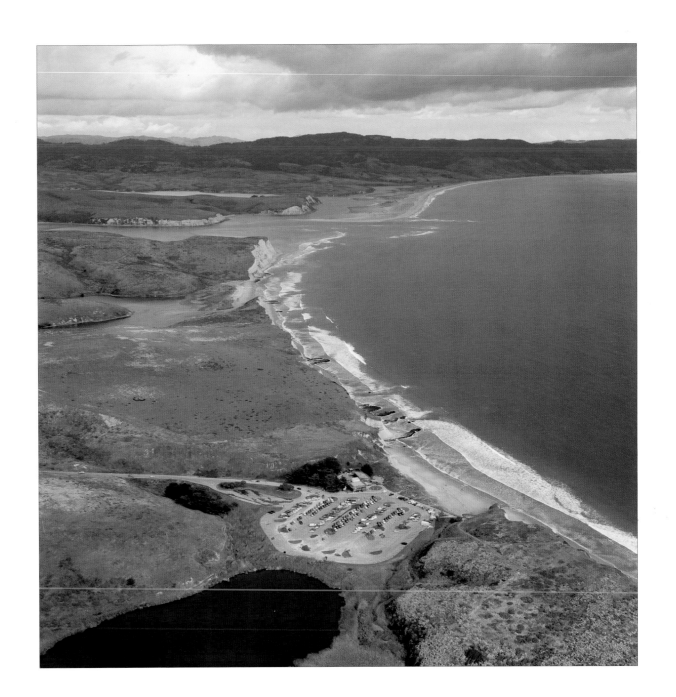

◀ THE ENTRANCE TO DRAKES AND LIMANTOUR
ESTEROS WITH DRAKES BAY AND
THE HEADLANDS IN THE DISTANCE
July 1995

▲ THE KENNETH C. PATRICK VISITOR CENTER
AT DRAKES BEACH
February 2006

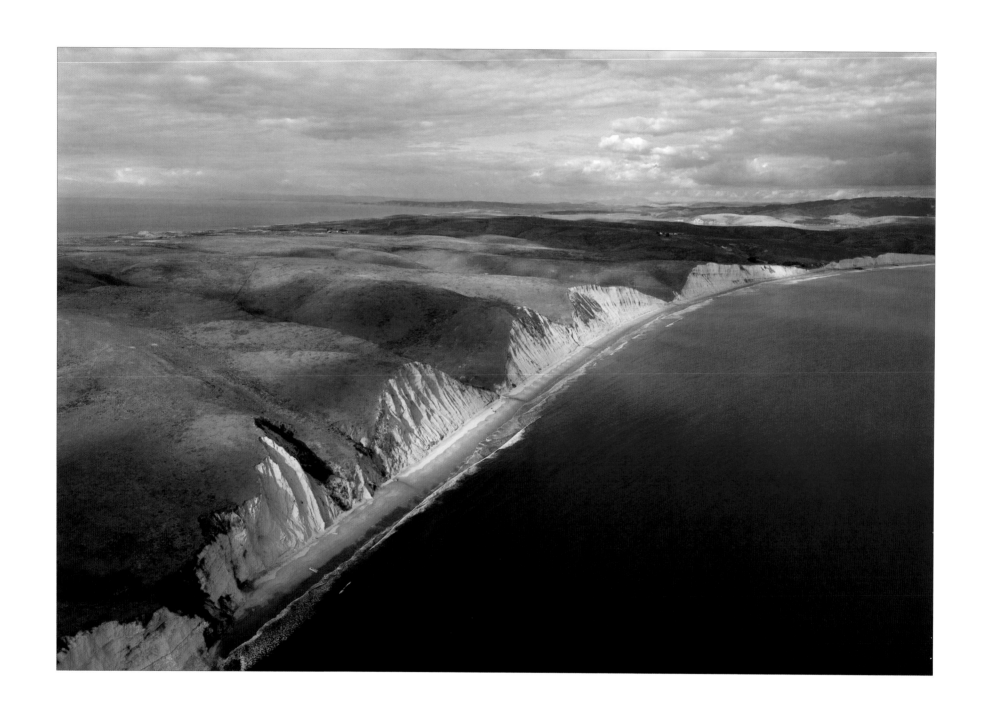

▲ The Cliffs above Drakes Beach
February 2006

▶ Drakes Estero with Tomales Point
and Jenner in the Distance
March 2001

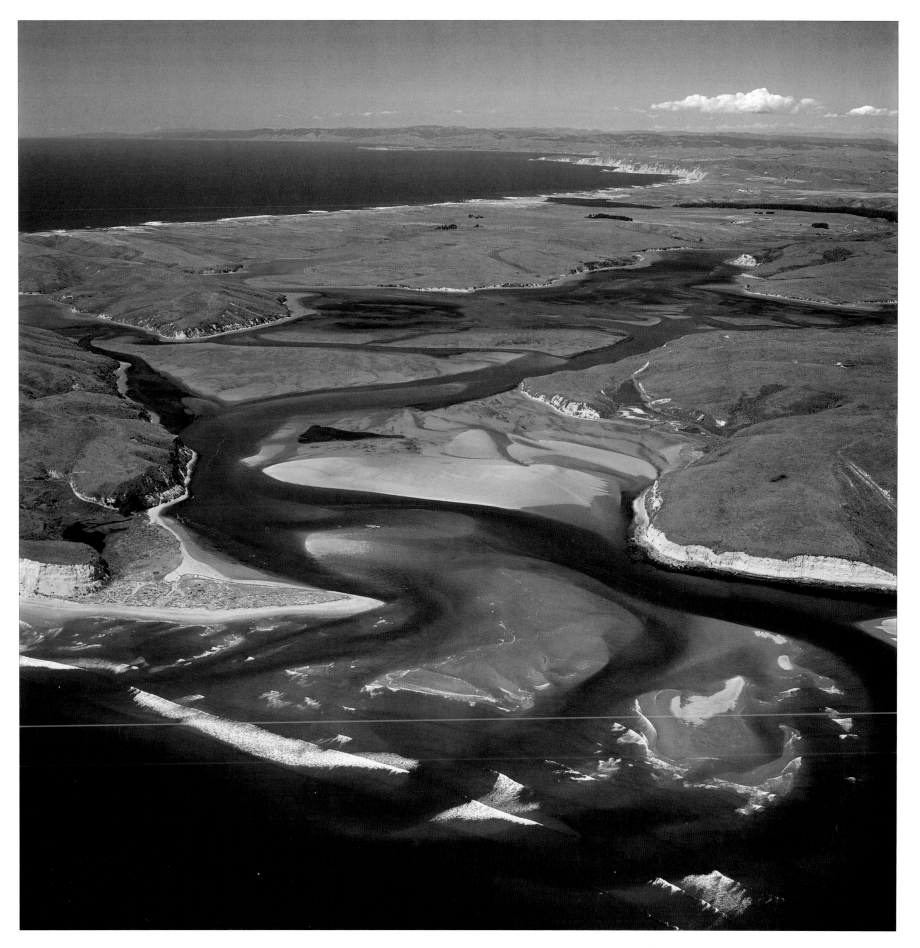

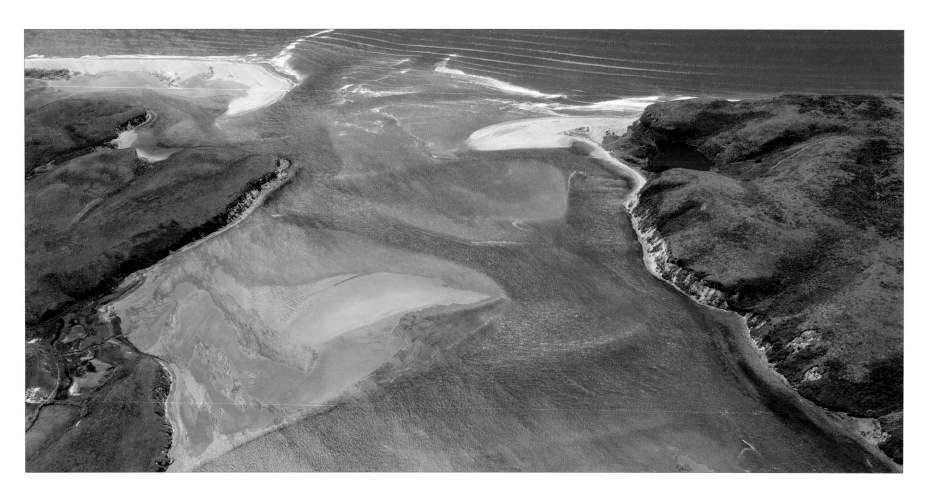

Lost Treasure of Drakes Beach

AFTER REPAIRING HIS WARSHIP, *Golden Hinde*, inside the entrance of Drakes Estero, (above and opposite pages), Francis Drake left behind a brass plate claiming the land for England. This valuable relic still awaits discovery.

In 1595, the treasure-laden Spanish galleon, *San Agustin*, anchored outside the estero mouth. A storm blew in from the South – Drakes Bay's unprotected side. The ship was driven onto the beach and pounded to pieces by the surf. Coast Miwok salvaged Chinese porcelain and other useful items from the wreck, but whatever else remains of the ship and its once precious cargo still eludes Park Service archeologists.

Today's visitors to Drakes Beach find treasures of a different sort: Miles of wind-sheltered shoreline, dramatic white cliffs, myriad shorebirds, breathtaking vistas of water and land.

▲ ENTRANCE TO THE ESTEROS
June 2006

▶ DRAKES BEACH
June 2006

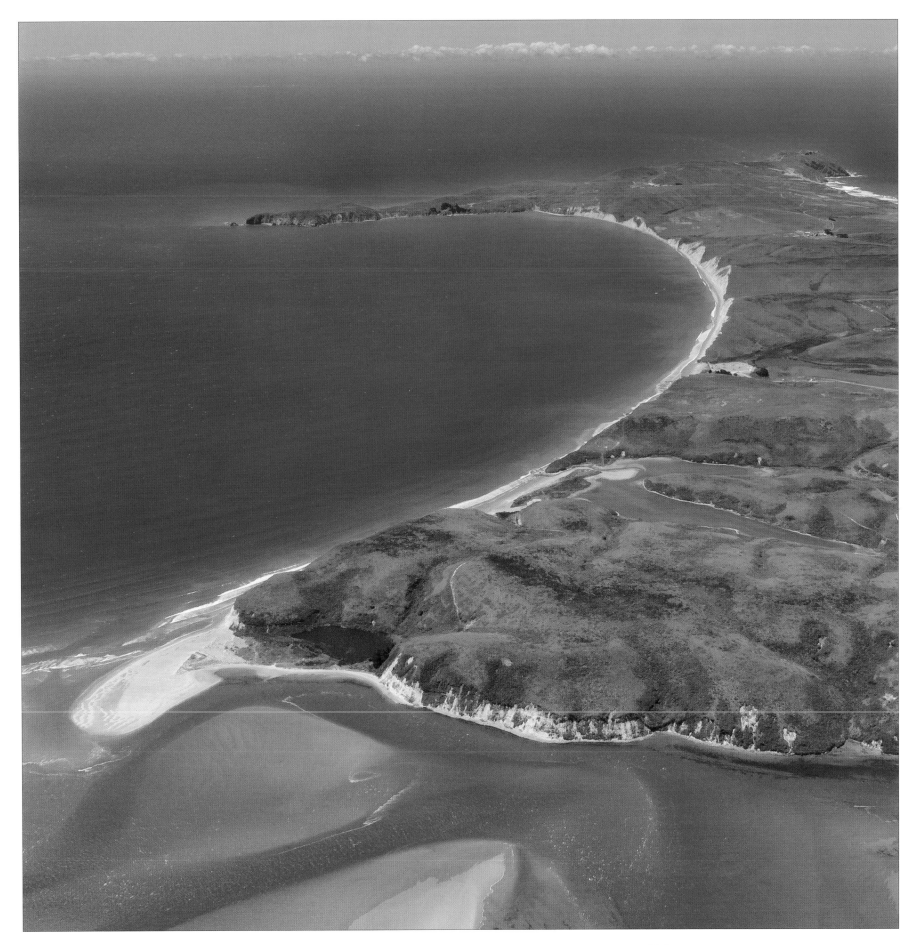

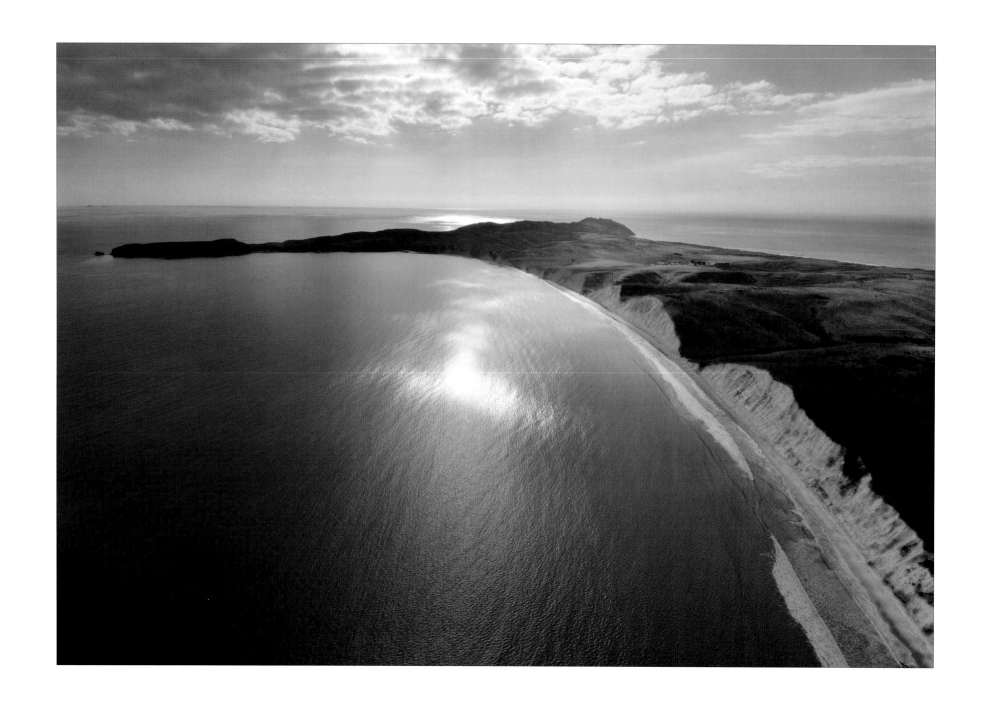

▲ DRAKES BEACH CLIFFS
February 2006

▶ DRAKES BEACH CLIFFS
June 2007

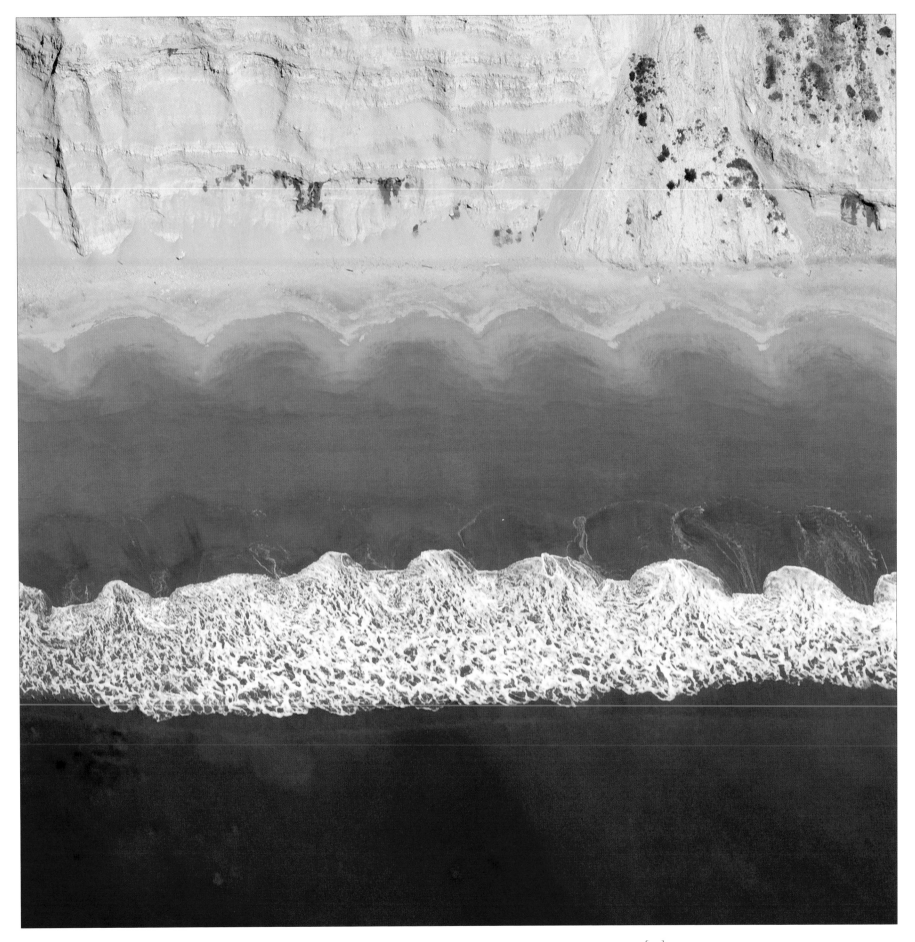

A Landscape
Painted by Fire

FIRES HAVE BLACKENED the Point Reyes landscape time and time again for thousands of years, bringing both destruction and renewal.

The peninsula's Coast Miwok people set fires in oak woodlands to improve the acorn harvest, and in grasslands to encourage new growth and greater diversity of edible plants. Mexican ranchers torched the coastal chaparral to convert hillsides of coyote brush, coffee berry and other native plants into cattle-friendly fields of introduced European grasses.

Recent attitudes favoring total wildfire suppression kept the Point Reyes peninsula free of major blazes for most of the 20th century. That changed one dry windy day in October 1995. The embers of an illegal campfire sparked a massive conflagration that consumed 45 private homes on Inverness Ridge and charred over 12,000 acres of natural beauty: Bishop pine and Douglas-fir forests, alder-lined stream courses, coastal scrub and grasslands.

Many feared the devastation would take a lifetime to heal. Nature, however, followed a faster track. Today new trees, shrubs and grasses hide almost all evidence of the inferno's destruction, while the landscape waits again.... For the next big fire.

▲ FIRE ZONE DETAIL

November 1995

▶ LIMANTOUR BEACH AND DRAKES BAY
A FEW DAYS AFTER THE FIRE

November 1995

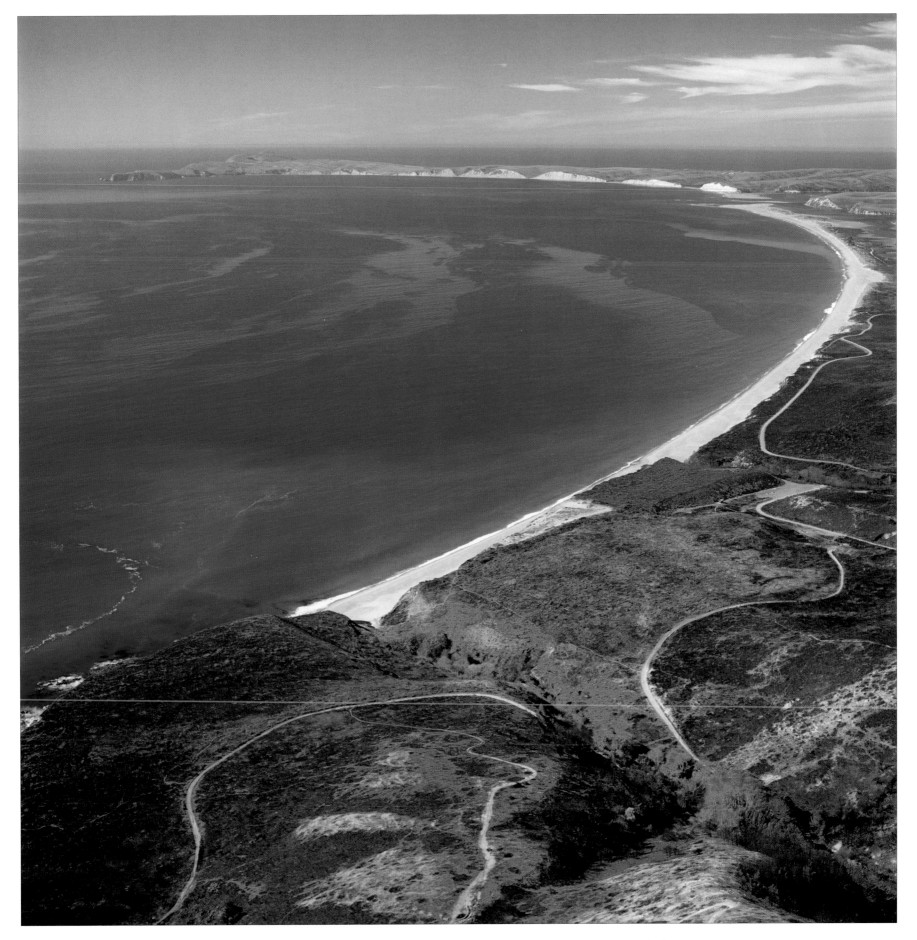

Treasures in the Ashes

THE 1995 FIRESTORM left a wide swath of barren land from the backbone of the peninsula to the dunes and coastal cliffs of Limantour Beach. Stripped of their concealing cloak of dense vegetation, ancient middens could again bear witness to thousands of years of Coast Miwok habitation. Long forgotten dump sites from turn of the century ranches also emerged from the ashes, providing clues to the day-to-day lives of more recent residents of the land.

Perhaps the greatest treasure yielded by the flames – at least for scientists – was the opportunity to study the burn zone in detail for years to come, discovering how ecosystems and individual species respond to fire's ageless role as destroyer, creator and transformer of the landscape.

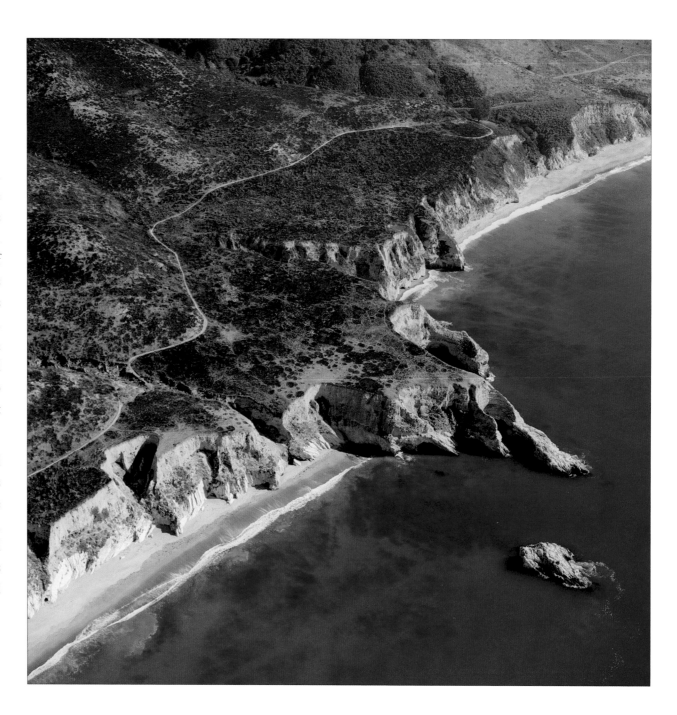

▶ FIRE ZONE DETAIL
November 1995

▲ POINT RESISTANCE TWO DAYS AFTER THE FIRE
November 1995

▶▶ SURF AT ENTRANCE TO THE ESTEROS
May 2006

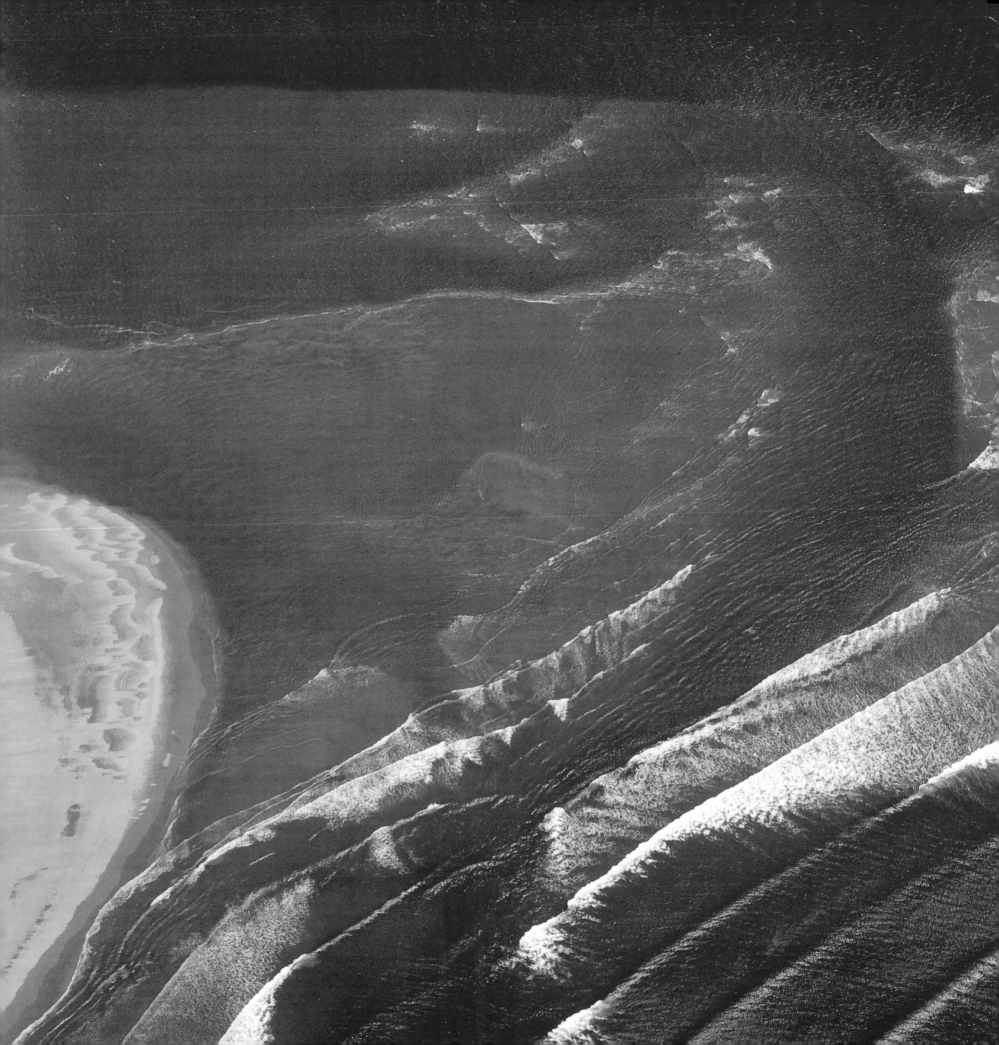

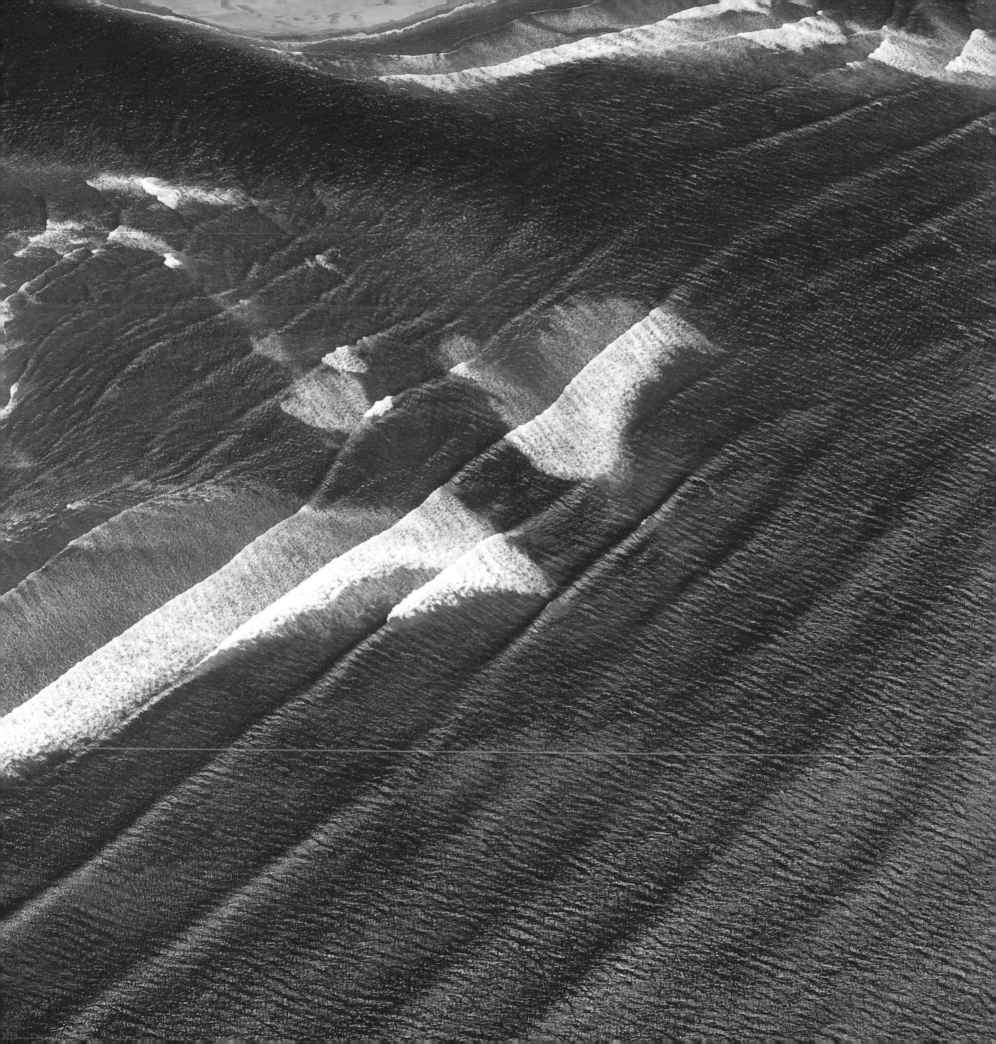

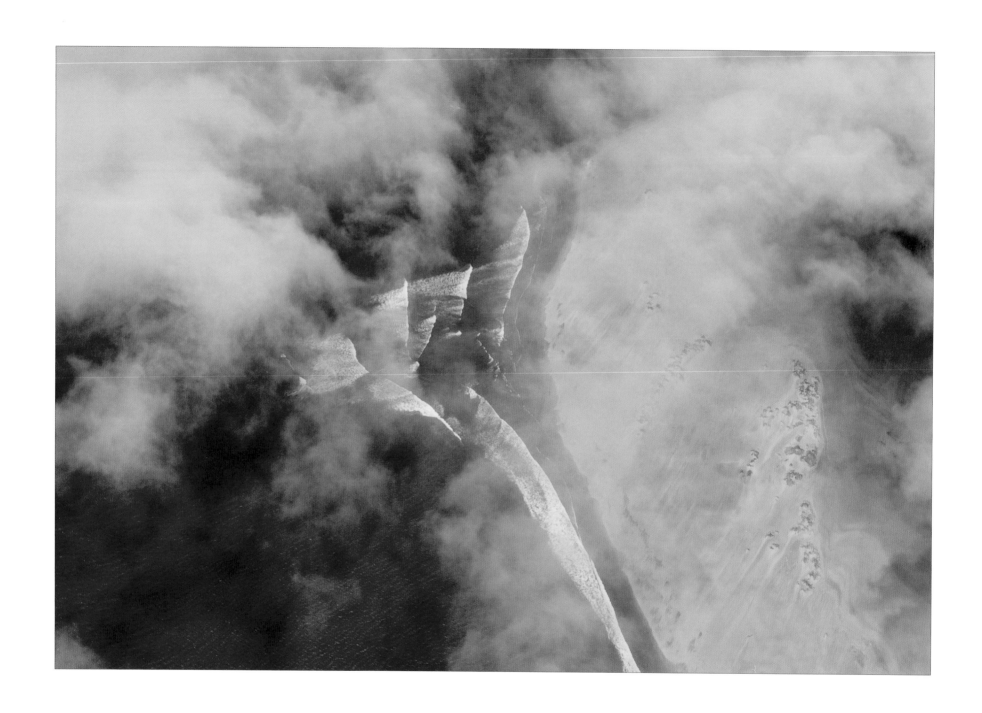

▲ Limantour Spit

June 2006

▶ Limantour Spit Looking

toward Mt. Tamalpais

June 2006

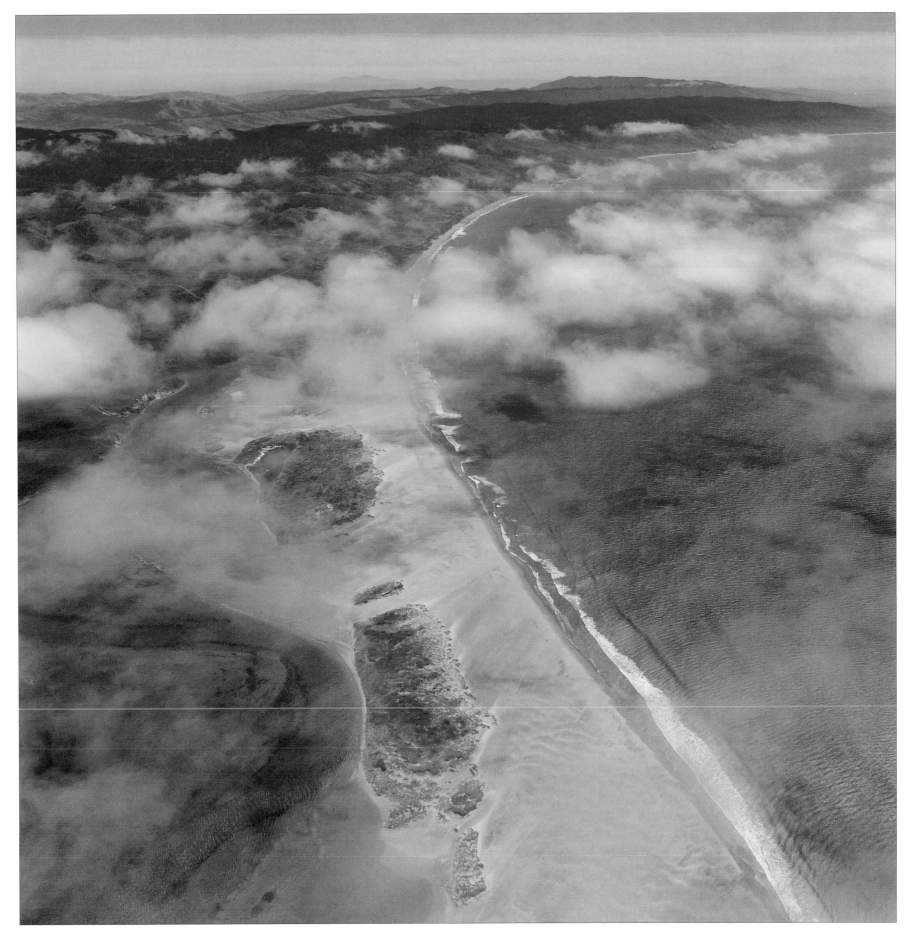

Rivers Drowned by the Sea

SAILING ALONG THE WHITE CLIFFS of Drakes Bay in his ill-fated Spanish galleon, *San Agustin*, 16th century explorer, Sebastian Cermeño, discovered what he assumed to be a large river flowing into the bay. He had, in fact, mistaken the wide mouth of Drakes Estero for the tidal zone of a river meeting the ocean.

Geologists now tell us Cermeño's river identification was not that far off the mark. The shallow saltwater bays of Drakes Estero and nearby Limantour Estero follow the courses of freshwater streams that once flowed into Drakes Bay. When sea levels rose, and movement along the San Andreas fault tilted this side of the peninsula downward, the ocean drowned the stream valleys, creating a vast haven for wildlife and an ever changing canvas of tidal patterns and abstract natural beauty.

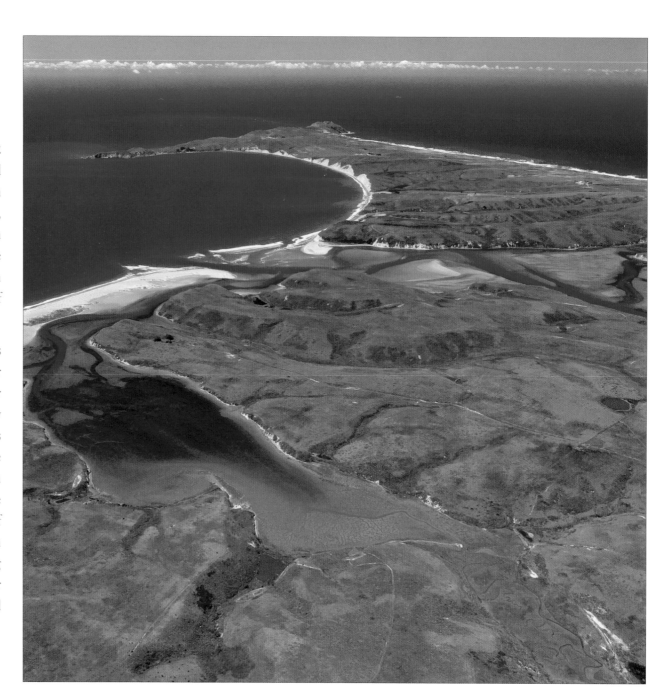

▲ LIMANTOUR ESTERO AND THE HEADLANDS
May 2006

▶ DRAKES ESTERO
May 2006

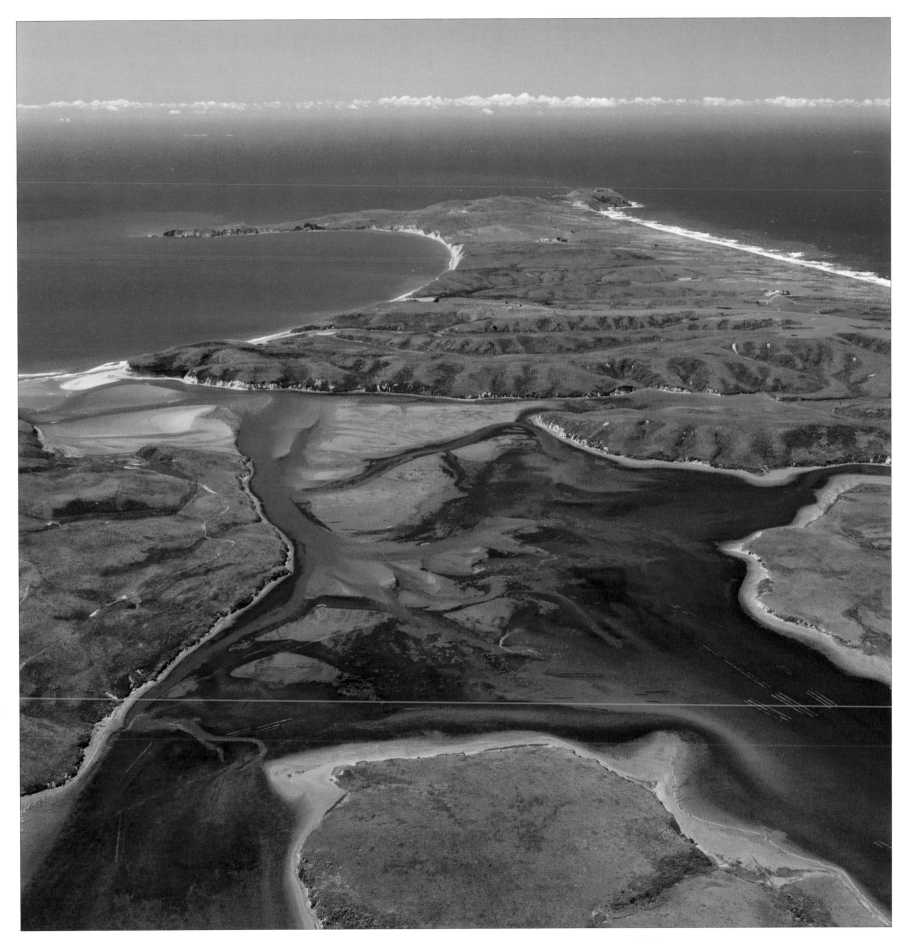

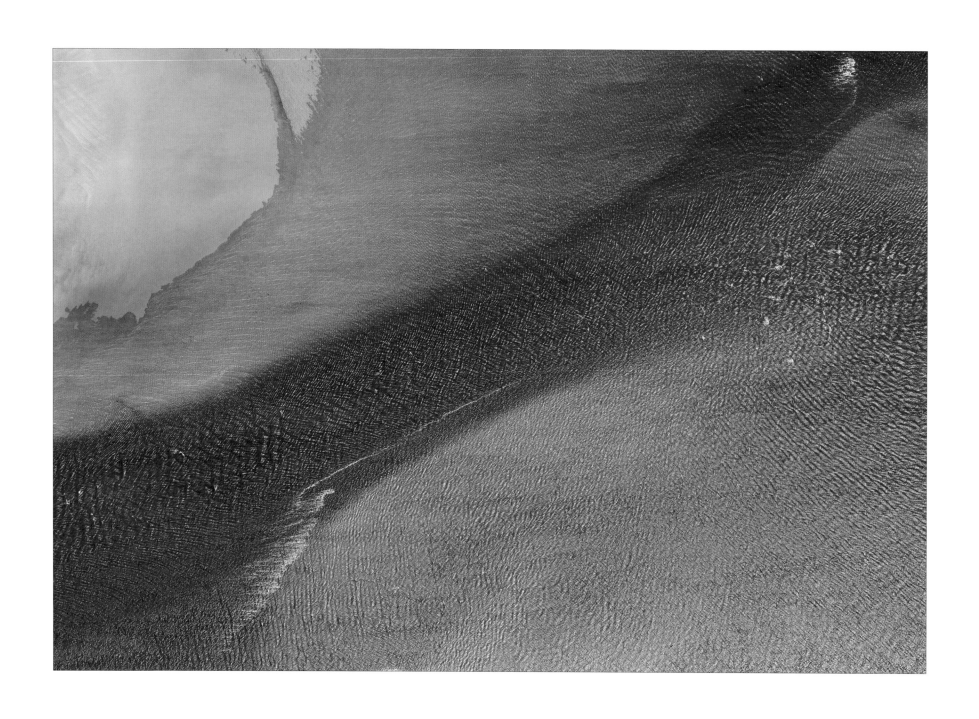

▲ Drakes Estero at Low Tide

May 2006

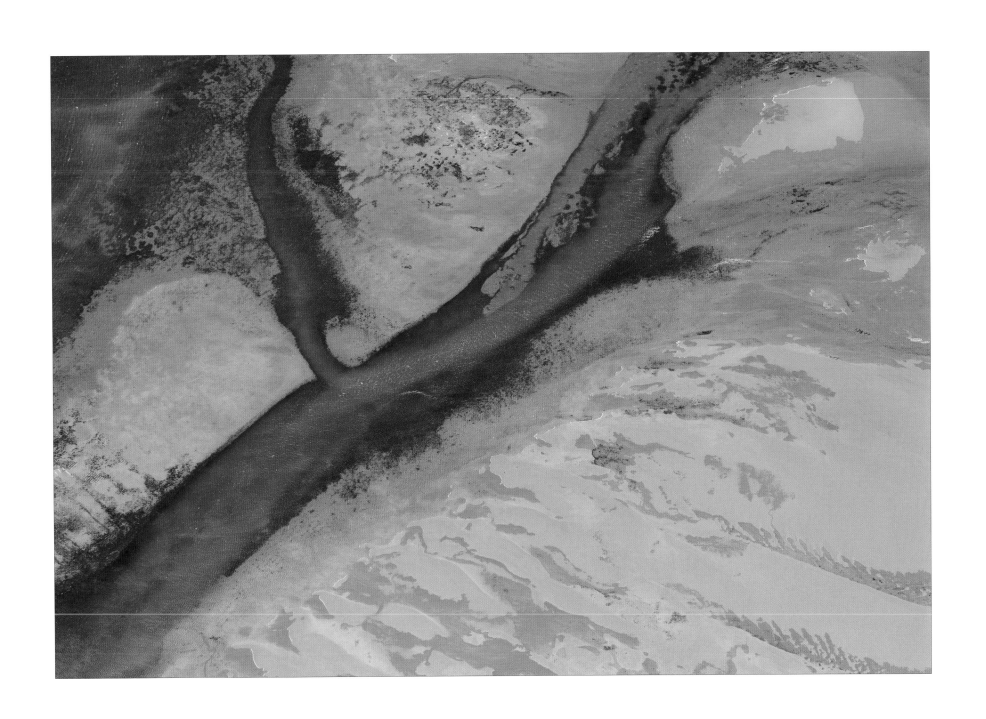

▲ Drakes Estero at Low Tide

May 2006

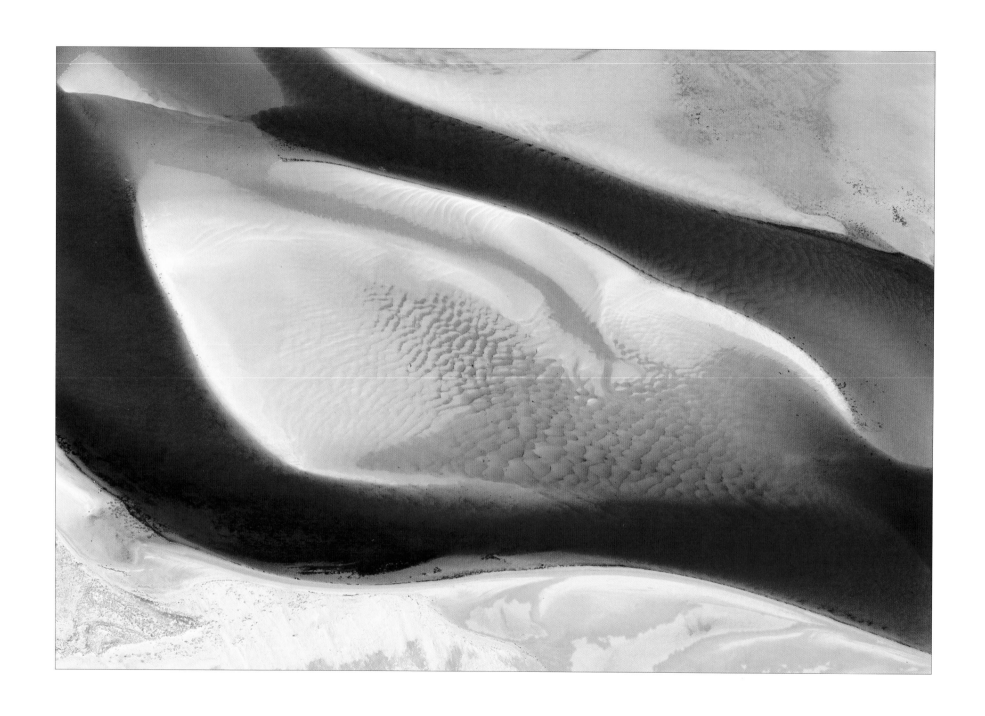

▲ Sandbar, Drakes Estero
June 2007

▶ Drakes Estero at Low Tide
May 2006

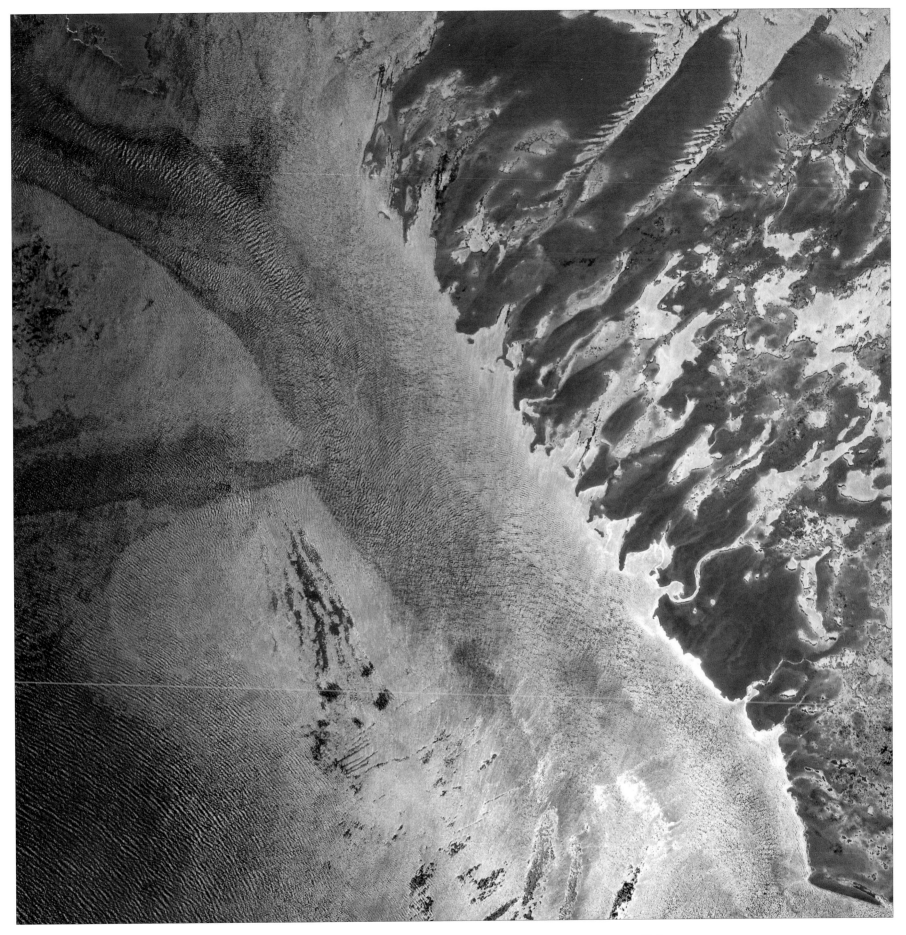

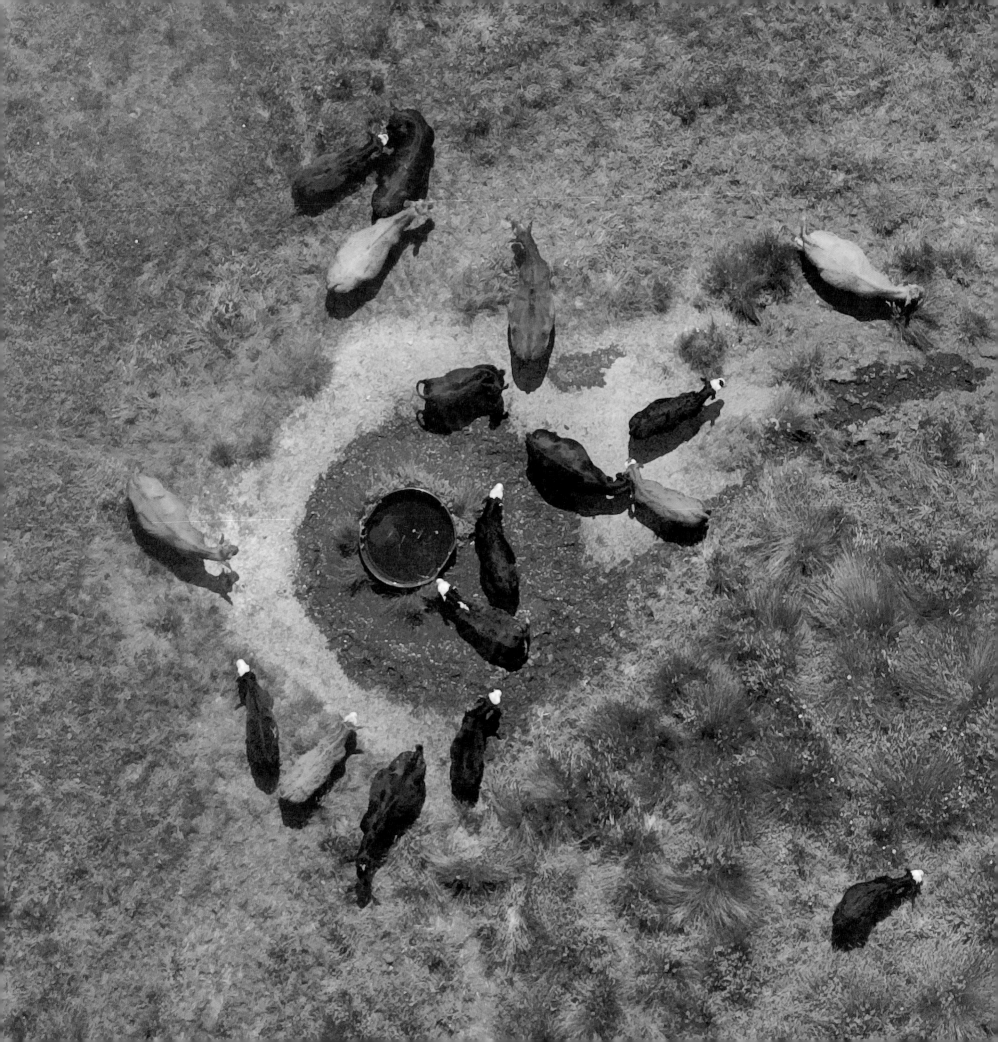

Tule Elk

Ranches

Pastoral Vistas Little Changed Since 1857

FROM THE AIR, the western coastal plain of the Point Reyes peninsula reveals the human-influenced patterns and designs of a historic working landscape, a montage of pastures, windbreaks, fields and feedlots interspersed here and there with century-old barns and modern utility buildings.

Developers' bulldozers once stood ready to level these dairy and cattle ranches for subdivisions and expensive vacation homes in the 1960s. The creation of the Point Reyes National Seashore prevented that fate and the National Park Service has allowed ranching to continue via long-term leases.

Some of the ranches in the coastal pastoral zone are still worked by families who trace their roots to the original immigrant tenants of the peninsula's historic "alphabet ranches". Beginning with "A" Ranch, out near the Lighthouse, and ending with "Z" Ranch, on the flanks of Mt. Wittenberg, these properties were owned by a single San Francisco law firm and operated as industrial dairies shipping butter and bacon via schooner to the City.

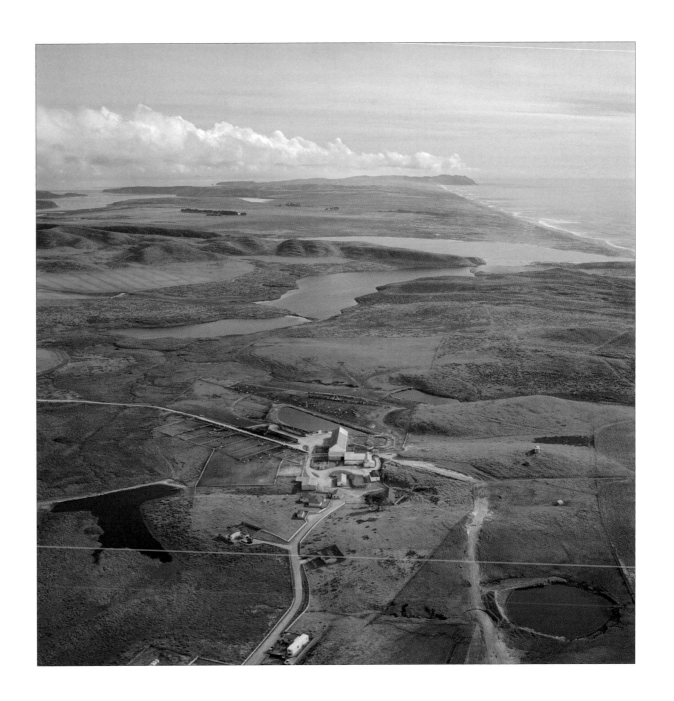

◀ Cows

May 2006

▲ McClure Ranch (Historic "I" Ranch)
Looking toward Abbotts Lagoon and the Headlands

March 1995

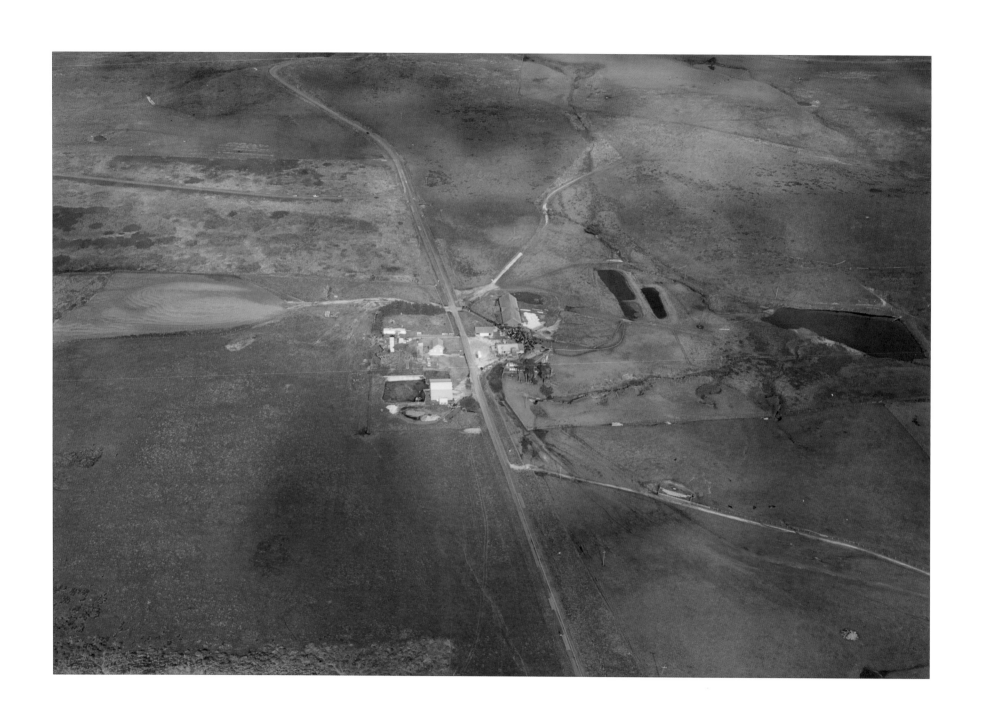

▲ SPALETTA DAIRY (HISTORIC "C" RANCH)
February 2006

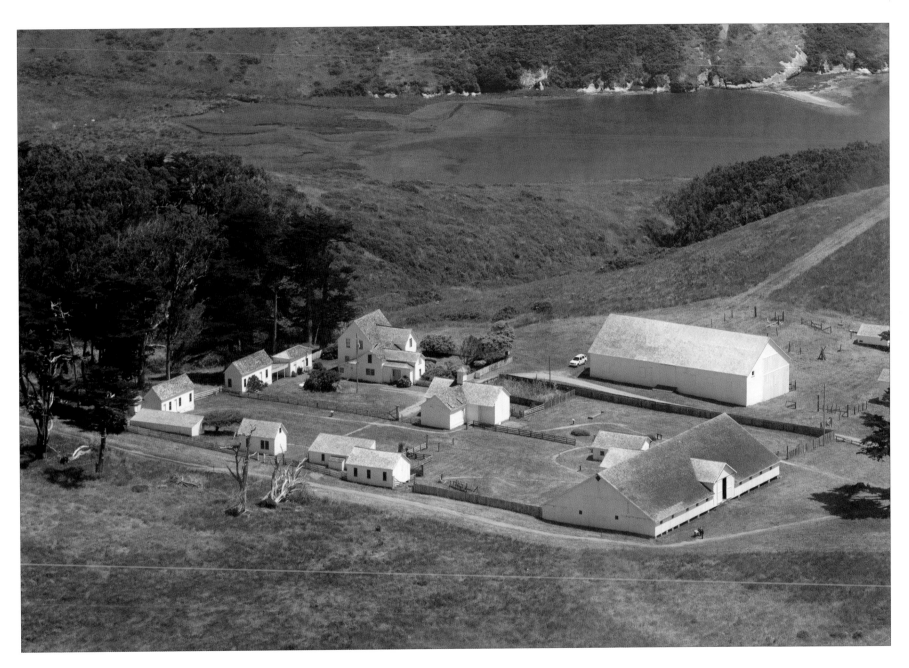

▲ PIERCE RANCH OVERLOOKING TOMALES BAY
 May 2006

▶▶ PIERCE RANCH THROUGH CLEARING FOG
 FIVE MINUTES EARLIER
 June 2006

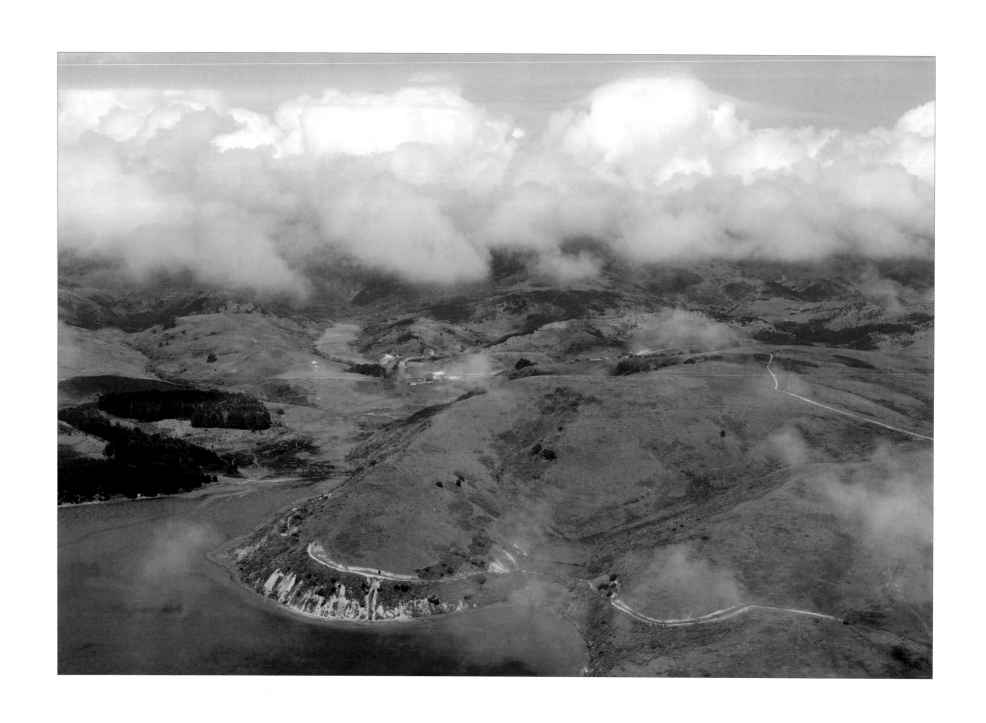

▲ Murphy Ranch (Historic Home Ranch)
 June 2006

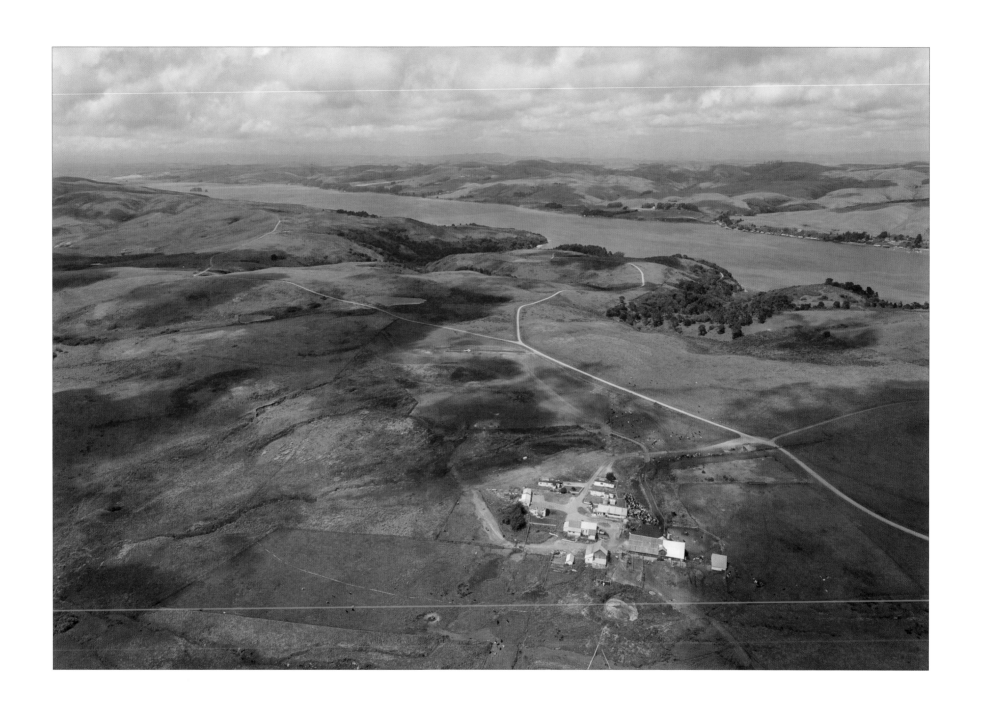

▲ "L" Ranch

May 2006

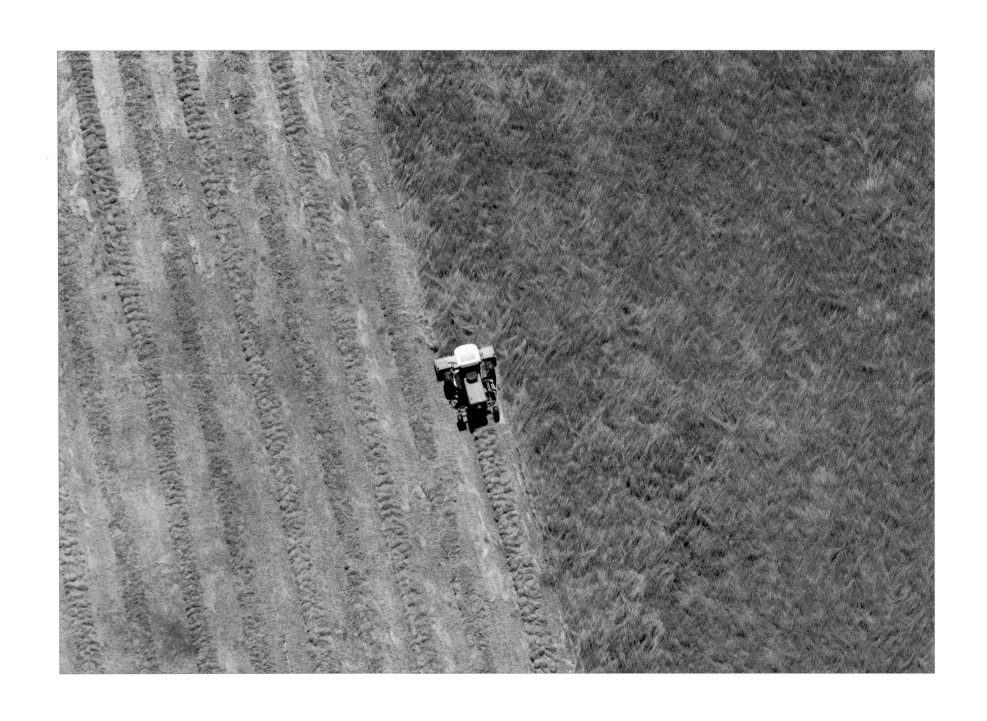

▲ Harvesting Silage, McClure Ranch (Historic "I" Ranch)

June 2006

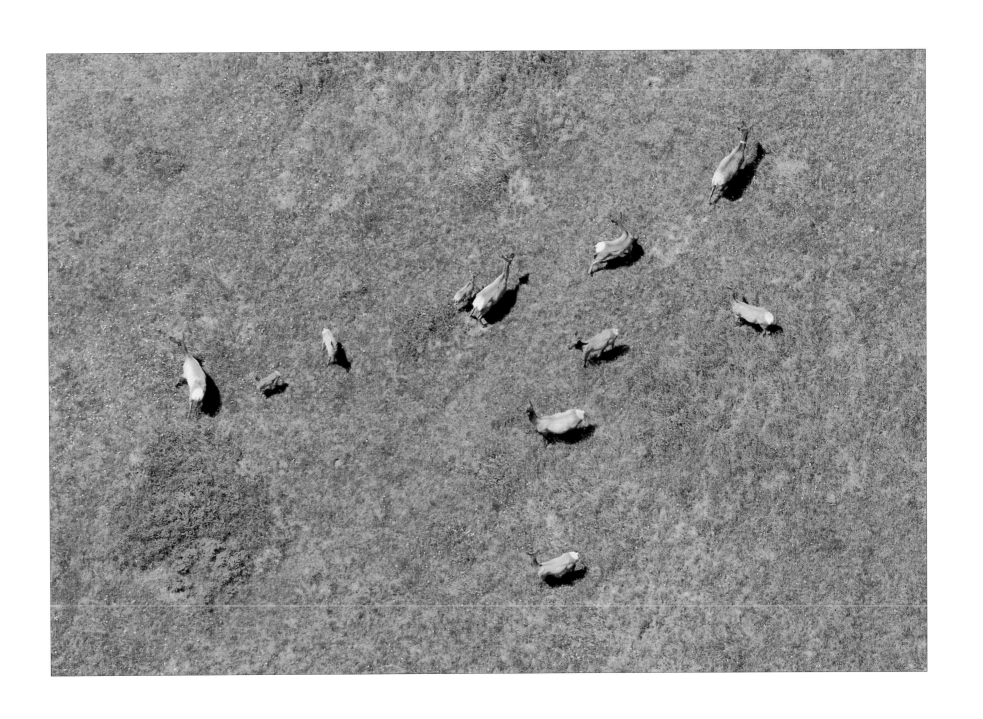

▲ Tule Elk, Pierce Ranch
June 2006

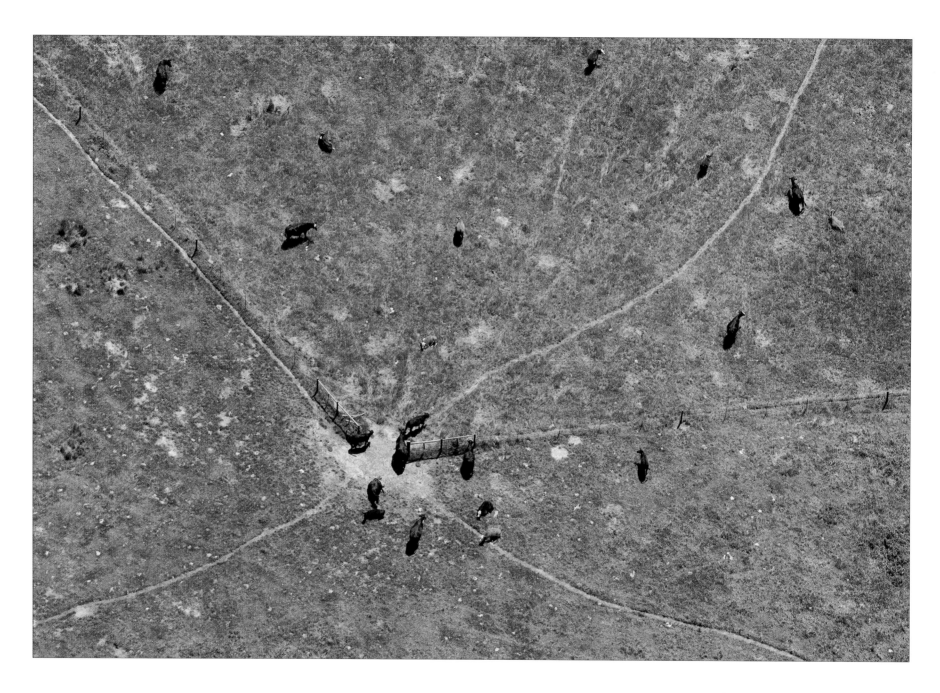

▶ Harvesting Silage, "L" Ranch
June 2006
▶▶ Sunset with Clouds over the
Point Reyes Peninsula
June 2006

▲ Cattle, "L" Ranch
May 2006

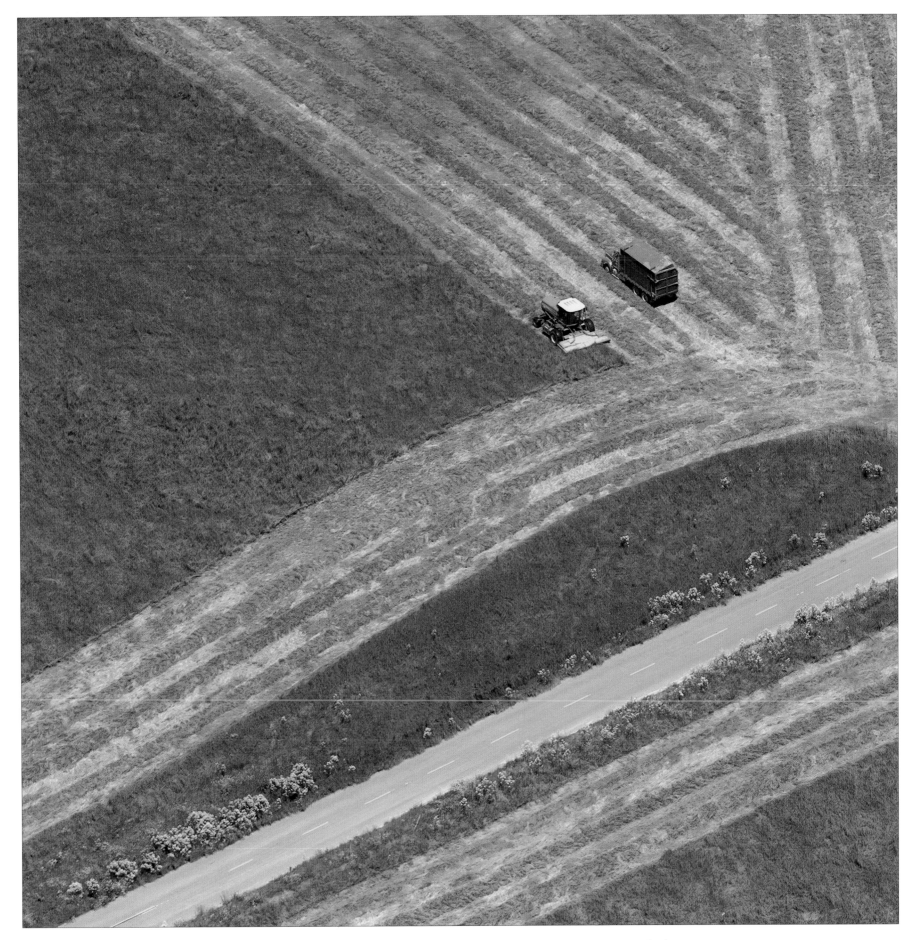

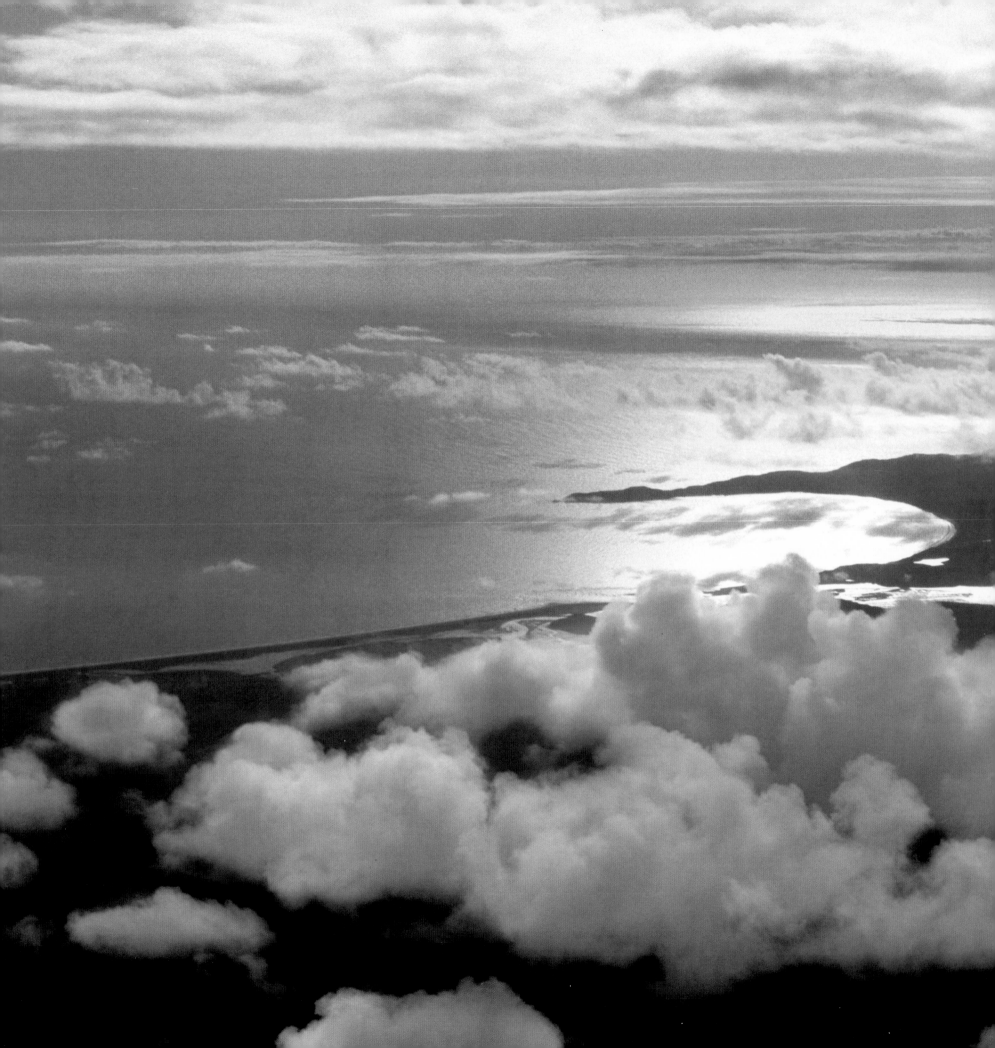

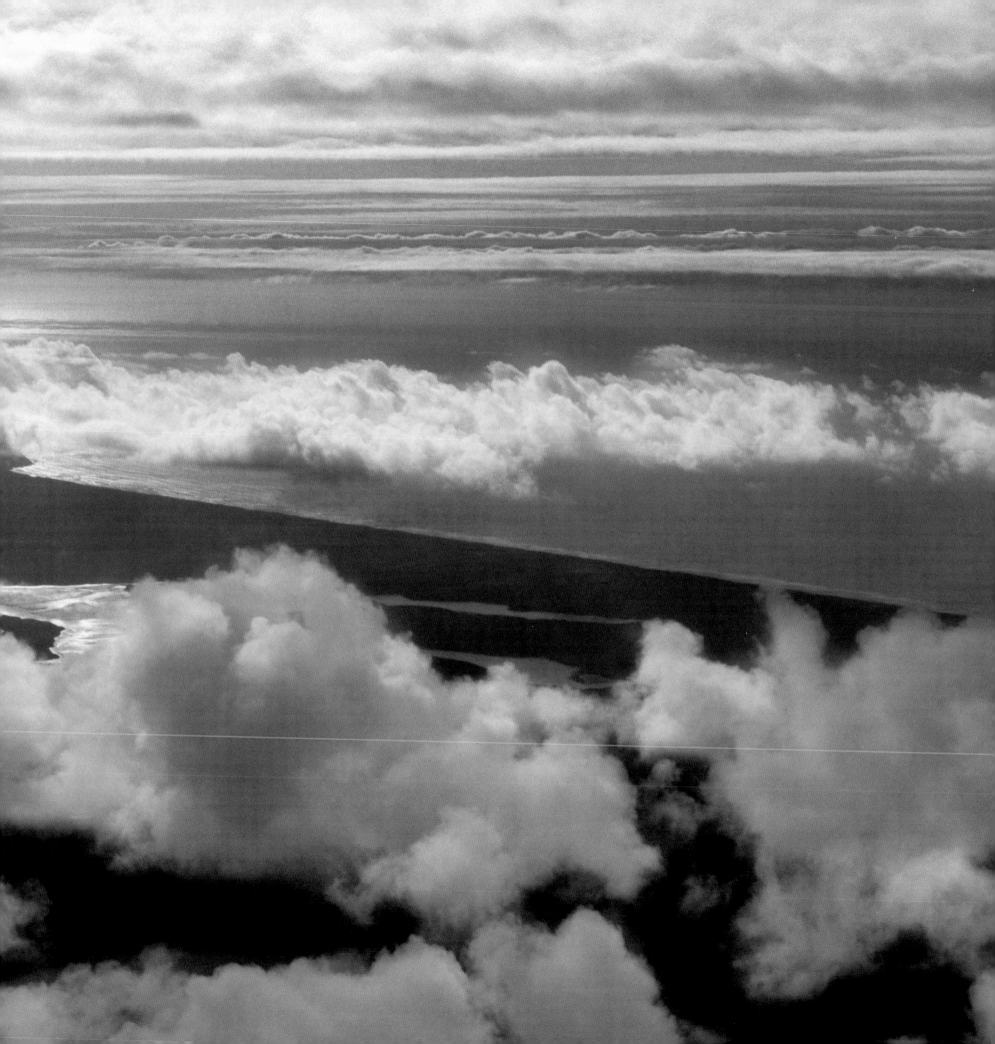

LADIES AND GENTLEMEN:

WE ARE DELIGHTED TO HAVE SHARED THESE

IMAGES WITH YOU TODAY. AS THIS BOOK

COMES TO A CLOSE, PLEASE FEEL FREE TO

ENJOY THE REMAINING PAGES.

THE CAPTAIN HAS REQUESTED THAT YOU

REMAIN SEATED WITH YOUR SEATBELTS SECURELY

FASTENED UNTIL THE BOOK HAS COME

TO A COMPLETE HALT.

– Jennifer Walker, Stewardess –

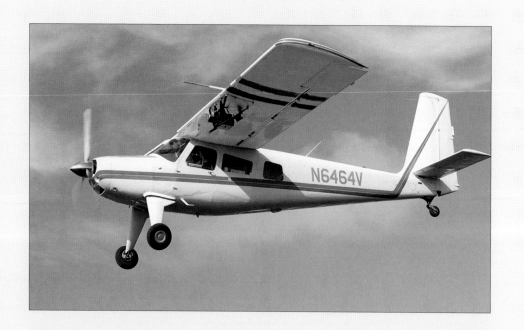

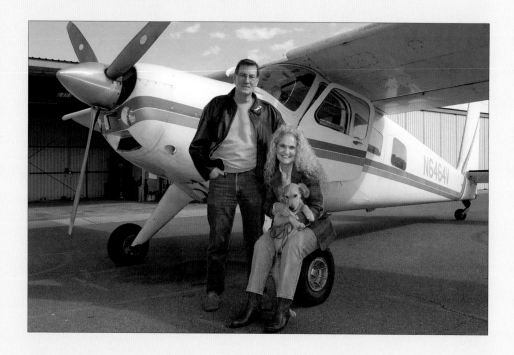

▲ *t.* 1969 HELIO COURIER H295 (NOTE VIDEO CAMERA MOUNT ON WING)
 Photograph by Jesse Campbell, 1992

▲ *b.* ROBERT AND JENNIFER CAMPBELL WITH THEIR TRUSTY NAVIGATOR, SCARLETT
 Photograph by Frank Binney, 2007

About the Photographer

ROBERT CAMPBELL'S LICENSE PLATE READS "DC3 CAPN." His wife Jennifer's car displays "DC3 CREW." They met in 1995 flying tourists over San Francisco Bay in a restored 1938 Douglas DC-3 airliner owned by Otis Spunkmeyer, Inc., (The Cookie Company). Campbell was a Captain; Jennifer a Stewardess. Yes, Stewardess! Gender-neutral terms such as flight attendant were decades away from the 1930s and 40s aviation era recreated by the Spunkmeyer flights.

It was in that same 1930s era that Campbell's father, Douglas, an avid amateur photographer and filmmaker, piloted an airplane he had purchased from his friend, Charles Lindbergh. Stories of his father's experiences fascinated Robert as a youngster growing up in San Francisco in the 1950s, sparking a lifelong passion for both flying and photography.

A Piper Cub pilot gave Campbell his first taste of small plane adventure at age twelve. Young Robert rode along as the tiny two-seat aircraft landed and took off from levee roads in California's Sacramento Valley, patrolling hunt club property for poachers. Campbell's most vivid memory of that first flight was watching a V-formation of flying geese overtake and pass the slow moving Piper!

Following high school years devoted to art, photography and skiing, (not necessarily in that order), Campbell enrolled at the University of Oregon, but dropped out after his freshman year to learn how to fly. In little more than a year, he earned his Commercial, Multi-engine and Instrument Pilot Certificates and began flying charter flights for an air taxi company in Oakland.

In 1967, he began studying photography at San Francisco State College with Don Worth and Jack Wellpott. A Yosemite summer workshop with Ansel Adams in 1968 led to an introduction by Ansel to Bill Garnett, the noted aerial photographer, who inspired Campbell to explore patterns from the air with his Hasselblad and Leica cameras.

Campbell continued photographic studies at SF State for the next two years, concentrating on color photography and printing with Don Worth. However, unlike the plant close-ups and other terrestrial-based images of his mentor, all of Campbell's photographs were aerials, including many abstract compositions of the multicolored salt ponds at the south end of San Francisco Bay.

In the 1970s, the air freight industry entered a period of rapid growth, and Campbell left college to pursue a full-time career as a "freight dog." Aviation pundits like to joke, "You might be a freight dog if your airplane was getting old when you were born, and you haven't made a daylight landing in the past six months." Robert certainly met those qualifications. He flew DC-3s and Beech 18s that first rolled off the assembly line in the late 1930s and early 1940s, and he flew them almost exclusively at night in all kinds of weather carrying cargo that ranged from lab rats to Marie Osmond's hats!

Nine years of night flying wore out Campbell's enthusiasm for the air freight business, so he returned to photography with a job at San Francisco's largest commercial color lab. A year later, he started his own lab and aerial photography business.

Now based in Sonoma, California, Robert Campbell Photography serves the aerial video and still photography needs of clients ranging from aviation companies, shipping lines and the Public Broadcasting Corporation to the National Park Service, the US Army Corps of Engineers and numerous other public and private companies.

For more information, please visit: www.chamoismoon.com

Notes from the Cockpit:

AIRPLANE 1969 Helio Courier, an aircraft specially designed for maneuverability at very low flying speeds, making it ideal for creative aerial photography. More information on the Helio Courier is available by visiting: www.chamoismoon.com/helio_courier.html

IN FLIGHT Robert Campbell often flies solo on his flights over the Point Reyes peninsula, utilizing the co-pilot's seat to keep two cameras with different lenses at the ready. When shooting, he aims his camera out the cockpit window with one hand while controlling the aircraft and operating a shutter release cable with the other. On flights in congested airspace or when he faces greater challenge, he always takes a co-pilot with him.

CAMERAS Photographs in this book taken prior to 2003 were shot with medium format Hasselblad 500 ELM cameras using Kodak color negative films. Campbell made a slow transition to digital in 2003, eventually settling on the Nikon D2X and D200 cameras he uses today, although he still shoots film for large murals.

AERIALS Campbell uses his Helio Courier as a tall, very mobile tripod to take *oblique* aerial photographs at various angles out the side of the aircraft. This differs from the other kind of aerial photography – vertical – which involves a camera mounted to shoot straight down to produce images used for mapping and surveying.

About the Contributors

FRANK BINNEY, WRITER, develops exhibits and writes interpretive text for museums and park visitor centers across the United States. He lives in the Tomales Bay watershed and volunteers regularly at the Point Reyes National Seashore as a wildlife docent, helping visitors make personal connections with the park's elephant seals, tule elk and snowy plovers.

Photograph by Kent Essex

MADELEINE GRAHAM BLAKE, BOOK DESIGNER, makes her living both as a fine arts photographer and graphic designer. An admirer of the aerial photography of Robert Campbell for many years, she was delighted to be part of the creation of this book. She now resides with her husband and dog in the Klamath Basin in northern California, but lived in Inverness Park for twenty years.

Photograph by Tupper Ansel Blake

JENNIFER WALKER CAMPBELL, CO-PILOT, PRODUCER, has shared this book's journey with Robert Campbell both in the cockpit and on the ground. An accomplished cellist who played for several symphony orchestras, as well as a former stewardess for both TWA and Otis Spunkmeyer's DC-3 tours, Jennifer finds time between flights with Bob to operate Aaron Entertainment, presenting the Corps d'Elite of professional musicians to California's Wine Country and San Francisco Bay communities.

Photograph by Robert Campbell

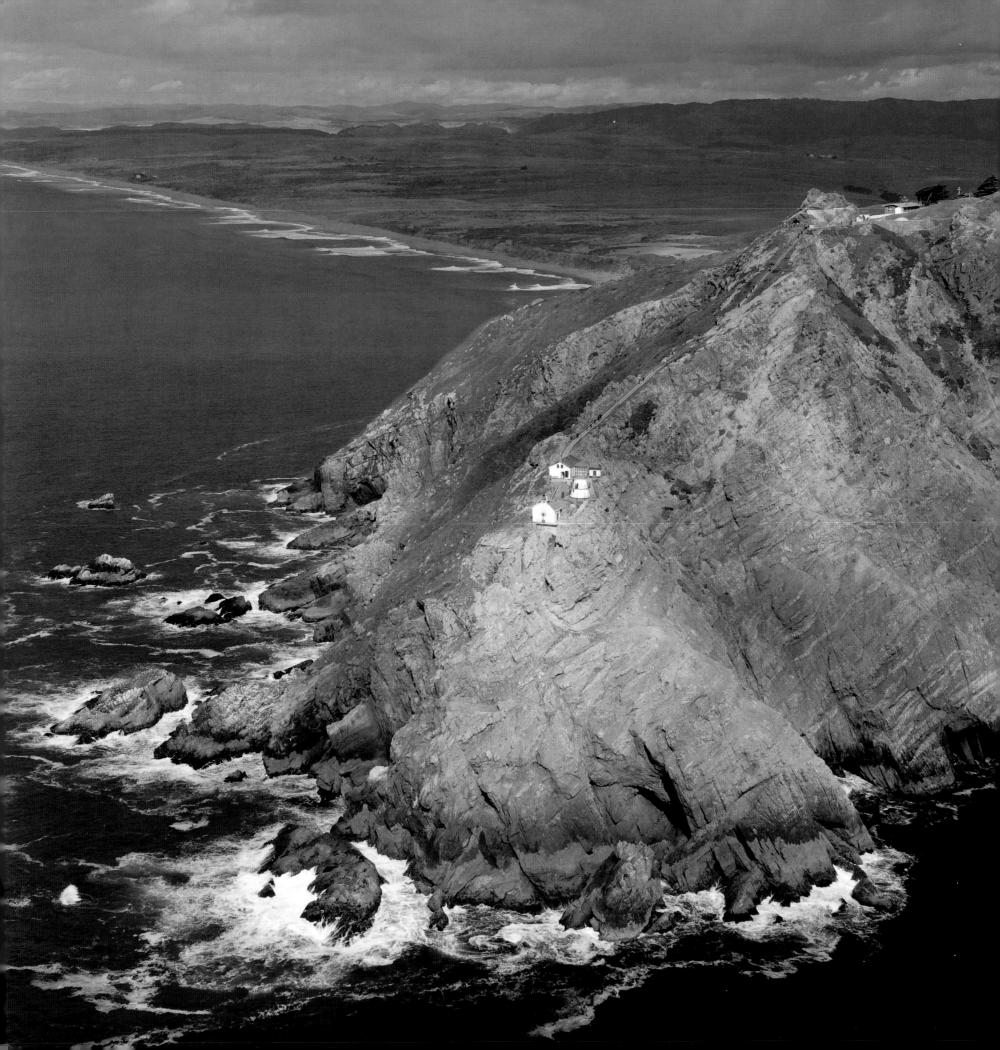

Acknowledgements

THIS BOOK AND THE PERSONAL LOVE OF THE POINT REYES NATIONAL SEASHORE THAT INSPIRED IT WOULD NOT HAVE BEEN POSSIBLE WITHOUT THE CONTRIBUTIONS OF MANY SPECIAL PEOPLE. WE WOULD SPECIFICALLY LIKE TO THANK THE FOLLOWING GROUPS AND INDIVIDUALS:

The remarkable woman whose inspiration, support and assistance nurtured this book from concept to reality, Robert's wife Jennifer Walker Campbell. *My best co-pilot ever – RC.*

My neighbor, Tom Dorff, I appreciate your invaluable assistance both in the air and on the ground. *RC.*

The administrators, scientists, resource management team members and protection rangers of the Point Reyes National Seashore who ensure this special place will remain unspoiled for future generations. We have been personally inspired and encouraged by Don Neubacher, John Dell'Osso, Sarah Allen, Natalie Gates, William Shook, Carola DeRooy, Kan Dhillon, Harold Geritz, Colin Smith, Angelina Gregorio, Dan Habig, Bruce Dombrowski and numerous others.

The staff and board of the Point Reyes National Seashore Association including bookstore manager, Annalisa Price, who helped guide this book's inception; and others, such as executive director, Jim Petruzzi, and Board President, Dennis Rodoni, who work to preserve the seashore and enrich the visitor experience.

The respected researcher and chronicler of Point Reyes history, Dewey Livingston, who has connected us to the historical and cultural stories of many of the buildings and places of the peninsula.

The frontline interpreters of the National Park Service, who give so selflessly of their time for so little money, to inspire Point Reyes visitors with the stories behind the scenery. Those who have made a difference in our appreciation of the park include Steve Anastasia, Melinda Repko, Jessica Taylor, Doug Hee and Craig Morgan.

The many local naturalists who have helped us understand and value the diverse natural treasures of the Point Reyes peninsula, especially Jules Evens, Rich Stallcup, David Wimpfheimer and Bob Stewart.

The "Energizer Bunny®" of Point Reyes peninsula hikers, Phil Arnot, who has introduced generations of visitors to the peninsula's secret places and magic moments.

The great environmental writer, Harold Gilliam, whose columns in the San Francisco Chronicle and whose pivotal book, *Island in Time*, set the standard against which all of us who write about the Point Reyes peninsula are measured.

The air traffic controllers at Oakland Center and NORCAL Approach, whose assistance and cooperation make aerial photography in our congested skies possible and safe.

So important, we acknowledge our tremendous debt to the visionary political leaders and citizen activists who worked so long and hard to bring to reality the dream of preserving the natural beauty of Point Reyes in a National Seashore: Clem Miller, Peter Behr, Stewart Udall, Paul McCloskey, William Duddleson, Katie Miller-Johnson, Clair Engle, Kay Holbrook, Barbara Eastman, Marty Griffin, Boyd Stewart, David Brower, Margaret Azevedo, Jean Barnard, Libby Gatov, Hal Craig, Bunny Lucheta, Ed Ryken, Eileen McClain and numerous others.

Recommended Reading:

SAVING THE MARIN-SONOMA COAST
Martin Griffin

ISLAND IN TIME: THE POINT REYES PENINSULA
Harold Gilliam, with photographs by Philip Hyde

THE NATURAL HISTORY OF THE POINT REYES PENINSULA
Jules Evens

POINT REYES NATIONAL SEASHORE TRAILS MAP
Tom Harrison Maps

POINT REYES NATIONAL SEASHORE AND WEST MARIN PARKLAND MAP
Wilderness Press

POINT REYES NATIONAL SEASHORE: A HIKING AND NATURE GUIDE
Don & Kay Martin

POINT REYES VISIONS
Richard Blair & Kathleen Goodwin

POINT REYES VISIONS GUIDEBOOK; WHERE TO GO, WHAT TO DO
Richard Blair & Kathleen Goodwin

POINT REYES: THE COMPLETE GUIDE TO THE NATIONAL SEASHORE AND SURROUNDING AREA
Jessica Lage

POINT REYES: SECRET PLACES, MAGIC MOMENTS
Phil Arnot

POINT REYES: A WILDLIFE JOURNAL
Stephen Trimble

POINT REYES: THE ENCHANTED SHORE
Stephen Trimble

POINT REYES, TWENTY YEARS
Marty Knapp

COLOPHON:

All Aerial Photographs: Robert Campbell
Sonoma, Californa

Text: Frank Binney
Woodacre, Californa

Book Design: Madeleine Graham Blake
Point Reyes Station, California

Proofing: Lorna Johnson, Jennifer Walker
Sonoma, California

Type: Janson family and Onyx display face
Layout: Adobe InDesign CS2 and CS3 on a Macintosh
Powerbook and Macintosh Quad G5

Paper: 157gsm GoldEast matte artpaper

Printed in China
by Lorna Johnson
of Global Interprint, Santa Rosa, California

◀◀ POINT REYES HEADLAND, WINTER
February 2006